CW01020558

Master Drawings · The Ashmolean Museum

MASTER DRAWINGS

Christopher Brown · The Ashmolean Museum · Oxford 2013

MASTER DRAWINGS
The Ashmolean Museum, Oxford
25 May 2013 to 18 August 2013

Generously supported by the Patrons of the Ashmolean Museum, Jean-Luc Baroni,
Lowell Libson Ltd, and the Tavolozza Foundation – Katrin Bellinger.

© Ashmolean Museum, University of Oxford, 2013

British Library Cataloguing-in-Publications Data
A catalogue record for this book is available from the British Library

ISBN 978 1 85444 278 9

All rights reserved. No part of this publication may
be transmitted in any form or by any means, electronic or mechanical, including
photocopy, recording or any storage and retrieval system, without the prior
permission in writing of the publisher.

Catalogue designed and typeset in Elena by Dalrymple
Printed and bound in Malta by Gutenberg Press

Front cover: detail from *Apostles* [cat.16] Raphael 1483–1520
Frontispiece: detail from *Henry Writing, Lucca, August 1973* [cat.71] David Hockney b.1937
Back cover: detail from *A Seated Girl* [cat.69] Gwen John 1876–1939

For further details of Ashmolean titles please visit:
www.ashmolean.org/shop

MASTER DRAWINGS

Director's Foreword

MAKING THIS SELECTION OF DRAWINGS FROM THE ASHMOLEAN'S SUPERB
holdings of drawings by European artists was not an easy task. I wanted the exhibi-
tion to show the range and quality of our collections but I also wanted to highlight
the different ways that artists over the centuries used drawing, whether in creative
sketches or in meticulously crafted studies. Looking closely at drawings is an in-
timate experience – we can see how the artist's hand, eyes and imagination are all
engaged in capturing an idea or representing a motif in graphic marks on paper.
While the exhibition traces a path through the history of drawing, from Albrecht
Dürer and Raphael around 1500 to David Hockney and Antony Gormley today, visi-
tors will, I hope, make many visual connections of their own. The linear energy of
drawing can be admired and enjoyed in works such as Raphael's expressive study
of an angel, Rembrandt's rapid sketch of Saskia in bed, or Degas's decisive image
of a jockey. And equally the delicacy and virtuosity of the graphic line is visible
in a variety of drawings by Carpaccio or Leonardo, Fragonard or Augustus John.
Artists have always turned to the human figure and to the landscape, observing and
studying through drawing their structures and emotive possibilities. In making my
selection I have tried to suggest different approaches to each of these major themes
in European art. The way that materials and techniques that artists chose to use
influenced their approach to drawing is the subject of one of the essays in this book.

The magnificent collection of drawings by Raphael and Michelangelo came to
Oxford in 1846 as the result of a public fund-raising campaign, and further major
acquisitions rapidly followed, with gifts and bequests of drawings by Leonardo,
Rembrandt, Claude Lorrain and J.M.W. Turner amongst others over the next
twenty years. How the Ashmolean's holdings of graphic art grew over the decades
to become one of the world's greatest collections is outlined in this book, and the
story is one of unremitting generosity by successive benefactors. We make our
European drawings available to the public in the Western Art Print Room, welcom-
ing students, artists or visitors who are simply interested in looking more closely
for themselves at these wonderful works of art. I hope that this exhibition will
encourage our public to discover more about our collections and about the enchant-
ment of drawing.

PROFESSOR CHRISTOPHER BROWN
Director, Ashmolean Museum

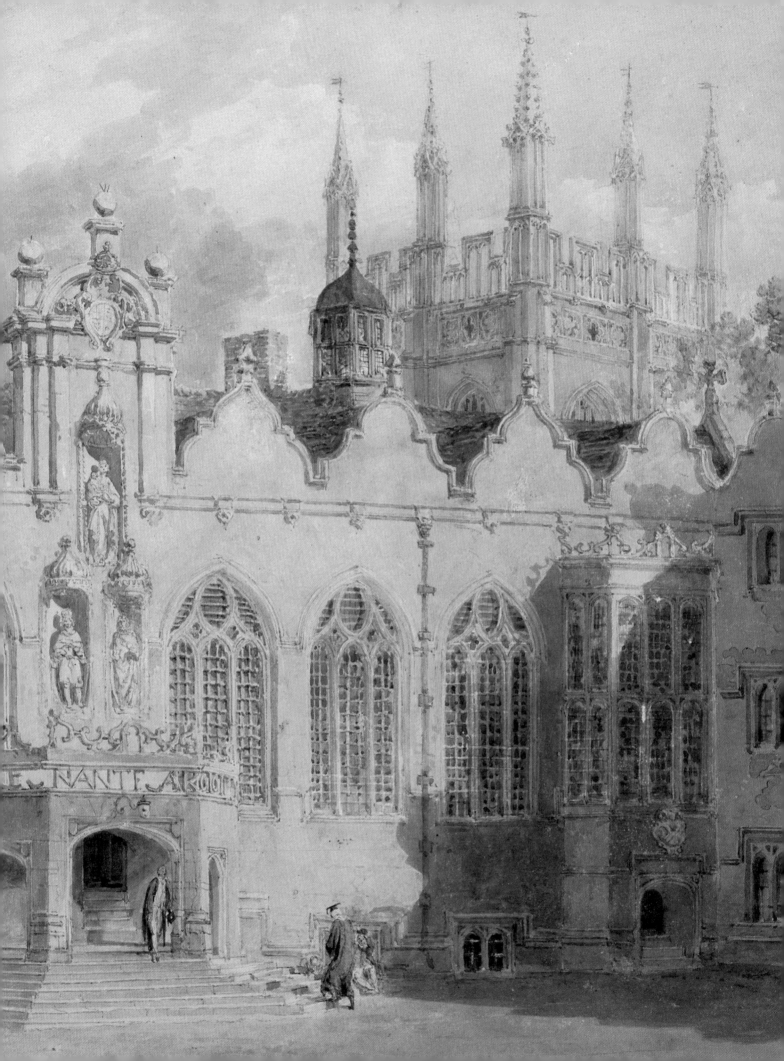

GENIUS AND GENEROSITY

The History of the Ashmolean Collection of Drawings

THE CENTRAL IMPORTANCE OF DRAWING TO BOTH THE ARTS AND THE sciences is pinpointed in the words attributed to Michelangelo: 'Design, which by another name is called drawing ... is the fount and body of painting and sculpture and architecture and of every other kind of painting and the root of all science.' Given the importance of drawing as a means of understanding and recording the natural world (and much else), drawings have always had an important place in education. At one time, drawings were collected by great libraries as much as books and manuscripts. As a result, the University of Oxford has one of the greatest collections of Old Master drawings in the world, including over fifty sheets by Michelangelo and nearly seventy by Raphael, now preserved in the Ashmolean Museum.

The inclusion of a collection of drawings was not foreseen when plans for the museum were drawn up in 1839. The University Galleries (as the present Ashmolean was then known) were chiefly built as a home for the Arundel collection of Greek and Roman statues that had been languishing since 1755 in two over-crowded, ill-lit rooms in the quadrangle of the Bodleian Library. The plans for the museum also included a large gallery on the first floor for paintings, added in the hope that future benefactors might fill the space with more interesting pictures than those then owned by the University. In due course, wonderful things were given or bequeathed to the Galleries but when the museum first opened, the main room in the upper floor was filled with seventy paintings from the Bodleian, nearly all of them copies or originals of little interest. Charles Robert Cockerell's brilliant, eccentric, theatrical building with its echoes of ancient Greece and the Italian Renaissance was a far more exciting spectacle than the paintings it contained.

In 1841, as soon as the University had decided to build the new museum, the Principal of New Inn Hall, John Antony Cramer, wrote to his close friend, Henry Wellesley (1791–1866) [fig.1], rector of Woodmancote in Sussex, to give him news of the decision. Cramer and Wellesley had known each other since their student days at Christ Church. A love of art, a devotion to their University and perhaps also their cosmopolitan backgrounds – Cramer was Swiss by birth and Wellesley's mother had been a French actress – brought them together. Both would have been familiar with the paintings in the Bodleian and, being well-travelled connoisseurs, would have known that they were second rate. In his letter, Cramer reflected on ways of improving the collection: 'Fine paintings we shall never be able to get, but

Joseph Mallord William Turner (1775–1851), *A View of the Chapel and Hall of Oriel College, Oxford* (detail), 1798–9, watercolour over graphite, 31.2 × 43.8 cm, Ashmolean Museum, University of Oxford, WA1850.49.

a selection of genuine old drawings we might very well hope to obtain.' Wellesley, who owned one of the finest collections of Old Master drawings in the country, replied enthusiastically:

> *My Dear Cramer – When I was last in London I called at Woodburn's and found him hanging up all his Raffaelle and Michel Angelo drawings, preparatory to an exhibition of them, before taking them abroad finally. They are wonderful! And I could not help thinking of your just observation regarding the new galleries at Oxford Now here is an opportunity, such as can never occur again, of forming at once a gallery which even without further outlay will never be surpassed. If it is neglected, we shall inevitably find ourselves in the same predicament as about paintings, viz. too late for the first-rate specimens. But these two masters once secured, the difficulty is over: second rate drawings are always to be purchased or presented, and are not much to be regretted. In short, if there are funds, they cannot be used more judiciously, more creditably, and I will make bold to say, more safely and profitably invested No time should be lost, if this grand subject is to be secured for* Alma Mater.

The exhibition seen by Wellesley consisted of a group of drawings by Raphael and Michelangelo that had previously belonged to the painter Sir Thomas Lawrence. It had been Lawrence's hope that his famous collection of Old Master drawings

[Fig.1] Alexander Munro (1825–1871), *Profile Portrait of Revd Dr Henry Wellesley*, 1856, Carrara marble, 54 cm diameter, Ashmolean Museum, University of Oxford, WA1857.4.

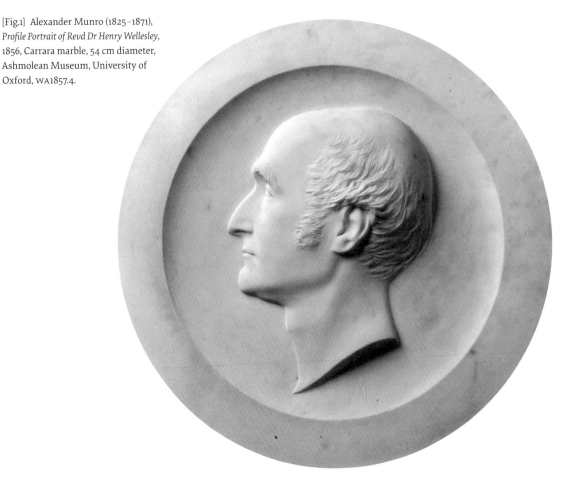

would be kept intact but attempts by his executor to interest George IV, the British Museum and several wealthy private collectors in acquiring the entire collection came to nothing. Lawrence's executor finally sold the drawings to the dealer Samuel Woodburn, who had advised Lawrence on forming his collection and hoped to keep it in a public museum. Wellesley was very familiar with the Michelangelos and Raphaels – he had acted as adviser to the government when the King of Holland was negotiating to buy some – and, with Cramer's approval and with the backing of the Vice-Chancellor, he set in hand a campaign to raise £10,000 to buy them for the Oxford museum. This was an ambitious undertaking. Many dons subscribed a pound or two but wealthy donors from London and the country did not come forward. The campaign would certainly have failed without a last-minute contribution from the Earl of Eldon who generously donated £4,000 towards the purchase and without Woodburn who, with equal generosity, lowered his asking price by £3,000.

In 1842 Wellesley came back to Oxford as Cramer's Vice-Principal at New Inn Hall, then one of the halls of residence of the University. Five years later, with the backing of his uncle, the Duke of Wellington, Chancellor of the University, he succeeded Cramer as Principal. He was also given a well-deserved role as one of the three curators at the new museum where his own influence and the fame of the drawings soon attracted other gifts. In 1850, the Clarendon Press deposited a large

[Fig.2] Joseph Mallord William Turner (1775–1851), *South View of Christ Church from the Meadows*, 1798–1799, watercolour with some pen and black ink over graphite, 31.5 × 45.1 cm, Ashmolean Museum, University of Oxford, WA1850.48.

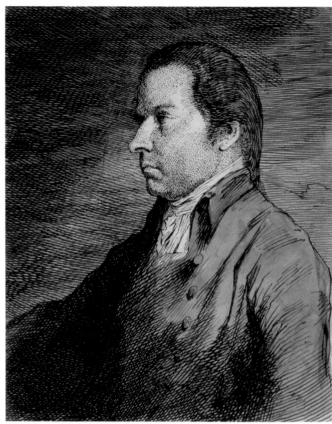

[Fig.3] John Linnell (1792–1882), *Portrait of Chambers Hall*, 1835, black and red chalk, with colour washes, 53.5 × 42.5 cm, Ashmolean Museum, University of Oxford, WA1949.65.

group of drawings made for the Oxford Almanack, the University calendar, which had been regularly illustrated with engraved views of Oxford since 1766. These included ten large watercolours painted by J. M. W. Turner between 1798 and 1801, the first of many works by Turner to enter the collection [fig.2]. In 1853, the Earl of Ellesmere presented a volume of drawings by or attributed to the Carracci, which the Earl had bought at one of the Lawrence sales. All these works, however, were eclipsed in splendour and importance by a gift in 1855 from Wellesley's friend, Chambers Hall, a collector and connoisseur from Southampton, who gave the museum a collection of drawings by Rembrandt [cat.24], Claude, Ostade, Leonardo (cats. 9 and 10), Sodoma, Raphael and many others, along with an important collection of prints and paintings, mainly by Flemish, Venetian and English artists.

Hall was a passionate, obsessive collector who divided his life between the pursuit of art and foreign travel. Landscape drawings and watercolours seem to have been a special interest, probably because he was himself a talented watercolourist. He gave a collection of watercolours by Girtin and some antiquities to the British Museum but selected an extremely rare view of the *Val de Cembra* by Dürer [cat.1], a beautiful woodland scene by Rubens [cat.31] and over thirty landscape drawings by Claude Lorrain for the University Galleries. Several of Hall's drawings, bought from Woodburn, had previously belonged to Lawrence and there seems no doubt that it was his desire to unite his drawings with Lawrence's Raphaels and Michelangelos that encouraged him to give preference to Oxford when distributing his treasures.

In 1863, the collection, now numbering over 600 items, was transformed by the

[Fig.4] James Barry (1741–1806), *Portrait of Francis Douce*, 1803, pen and brown and black ink with grey wash, 29.5 × 24 cm, Ashmolean Museum, University of Oxford, WA1999.14.

[Fig.5] Albrecht Dürer (1471–1528), *Portrait of Hans Burgkmair*, 1518, charcoal on discoloured paper, touched with brush and bodycolour, against a background of Indian ink, 37.4 × 26.5 cm, Ashmolean Museum, University of Oxford, WA1863.416.

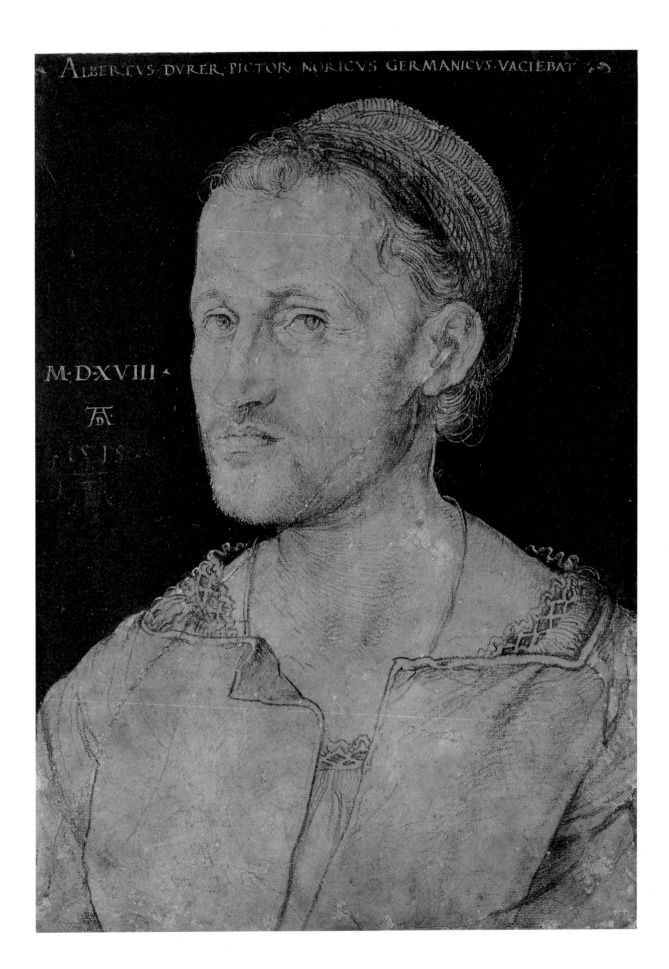

ALBERTVS·DVRER·PICTOR·NORICVS·GERMANICVS·VACIEBAT

M·D·XVIII·

arrival of more than 20,000 prints and 1,500 drawings from the collection of books, coins, manuscripts and works of art bequeathed to the Bodleian Library in 1834 by the antiquarian Francis Douce [fig.4]. This was one of the greatest benefactions in the history of the University. Douce's former colleagues at the British Museum, where he had been appointed Keeper of Manuscripts in 1807, must have hoped that he would leave his collection to their museum, but Douce who was notoriously irritable and unforgiving had resigned in 1811 in a fit of anger, citing among his reasons for this action, the constant interference in his work, the repulsive manners of his colleagues, the cold and the damp in the museum, the 'system of espionage throughout the place' and 'the fiddle faddle requisition of incessant reports'. It was perhaps as well that he came to the Bodleian, not as an employee, but as a highly respected visiting scholar who was shown every courtesy by the librarian. He was also impressed by the organisation of the collections and by the habit in the library of honouring the names of donors. It was said by the writer Isaac D'Israeli, who came with him on this occasion, that Douce decided on the spot to bequeath his treasures to Oxford.

Douce was more interested in prints than he was in drawings and acquired many of his drawings either because they were by a printmaker or because they had a link with printmaking. Dürer's portrait of Hans Burgkmair [fig.5], a portrait of one of the greatest printmakers in sixteenth-century Germany drawn by one of the greatest printmakers of all time, must have been an irresistible acquisition. His collection of drawings was particularly rich in rarities and masterpieces by Flemish and German artists, although he also collected works by British and French artists that appealed to his interest in printmaking and in certain subjects that appear with regularity among his prints and drawings: witchcraft, games, dancing, music-making and, in general, any images illustrating social life [fig.6].

Few drawings by the Old Masters were added to the collection in the sixty years after 1863. There were many collectors of Old Master drawings at the time who might have donated drawings to the Galleries but with the death of Wellesley in 1866, the direction of the museum changed. Henry George Liddell (father of Alice Liddell, immortalised as Alice in Wonderland), who joined the Board of Curators in 1858, and Henry Acland who joined in 1866 were more interested in supporting living artists than they were in collecting the work of the Old Masters. Both were long-standing friends of the art critic and writer John Ruskin, who had been a student at Christ Church in the 1830s and who, encouraged by Acland, began to take an interest in management of the Galleries in the 1860s.

Ruskin profoundly disliked the work of some modern artists but he passionately supported the work of others. In 1861, he gave the Galleries thirty-eight watercolours by his hero J. M. W. Turner and twelve others which are now attributed to William Turner of Oxford. These watercolours included three evanescent views of Venice [cat.50] and twenty-four jewel-like views of the *Rivers of France* [fig.7] that were among Ruskin's most prized possessions. Ruskin intended his gift to show that a great modern artist could hold his own alongside the best of the Old Masters.

He also set out to downgrade the work of certain artists of the past who were then revered as gods by connoisseurs and collectors. In 1871, he told an Oxford audience that must have included several of those who had subscribed to buy the Lawrence drawings that Michelangelo's drawings appealed mainly 'to comparatively weak and pedantic persons'. He detested the drawings by Claude which were (and remain) among the treasures of the collection, and was equally critical of the work of Raphael.

In 1869, with support from Acland, Ruskin was appointed Oxford's first Slade Professor of Fine Art and used the opportunity to speak on art with a dogmatic fervour that made his lectures hugely popular. In 1871, he set up the Ruskin School of Drawing in the Galleries and gave it over 1,400 prints, drawings and photographs that are now in the Western Art Print Room. These included more than three hundred drawings by himself [fig.8] as well as drawings and watercolours by Turner and the Pre-Raphaelites. He hoped that by studying great drawings, the undergraduates would become better members of society. His aim in setting up the school was not to train professional painters but to promote interest in modern British art and to teach students to look at the world with an 'innocent eye', unclouded by prejudice and convention.

[Fig.6] Anonymous (Flemish), *Satirical Subject: An Ass playing a Portable Organ*, c.1480, pen and bistre, 20.3 cm (diameter), Ashmolean Museum, University of Oxford, WA1863.134.

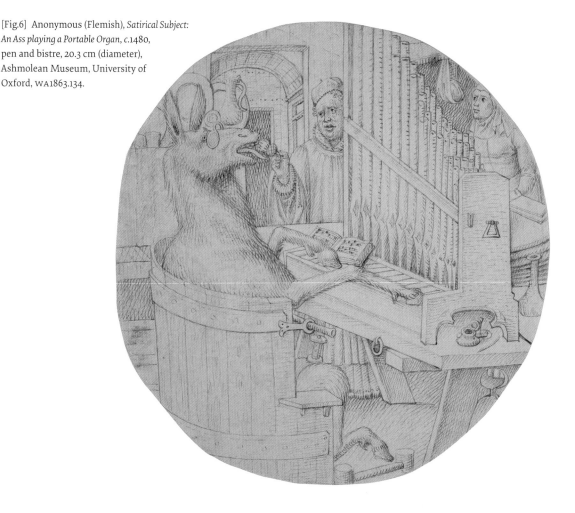

[Fig.7] Joseph Mallord William Turner (1775–1851), *Calm on the Loire*, c.1832, watercolour with bodycolour and pen and brown ink on blue paper, 13.8 × 18.8 cm, Ashmolean Museum, University of Oxford, WA1861.19.

Charles Francis Bell [fig.10] was appointed first Keeper of Fine Art when the Ashmolean Museum, formerly housed on Broad Street, and the University Galleries were amalgamated in 1908. Bell continued to acquire watercolours by Turner and his contemporaries but made little effort to add drawings by the Old Masters and had a limited taste for the work of his contemporaries. He was a Keeper with fixed views and a tendency to despise those who did not share them. It was perhaps the narrowness of his opinions and the tenacity with which he held them that explains why he did not acquire drawings across a wide range of art but was brilliantly successful in forming a collection of works by the English watercolourists in which he had special interest.

Although Bell had almost no funds for buying works of art, he had a talent for persuading others to give or bequeath them to the Ashmolean. During his keepership he acquired a large number of drawings and watercolours by Thomas Girtin, Edward Dayes, John Robert Cozens [cat.48], John Baptist Malchair and others from collectors and from descendants of the artists whom he courted with a mixture of diplomacy and determination. Caught in the middle of a furious row between the daughters of Alfred William Hunt, both of whom had offered rival collections of their father's work, he delicately turned one offer down and secured the best

[Fig.8] John Ruskin (1819–1900), *The Baptistery, Florence: Study of the Upper Part of the Right-hand Compartment on the South-west Façade*, 1872, watercolour and bodycolour over graphite, 52 × 34.6 cm, Ashmolean Museum, University of Oxford, WA.RS.REF.120.

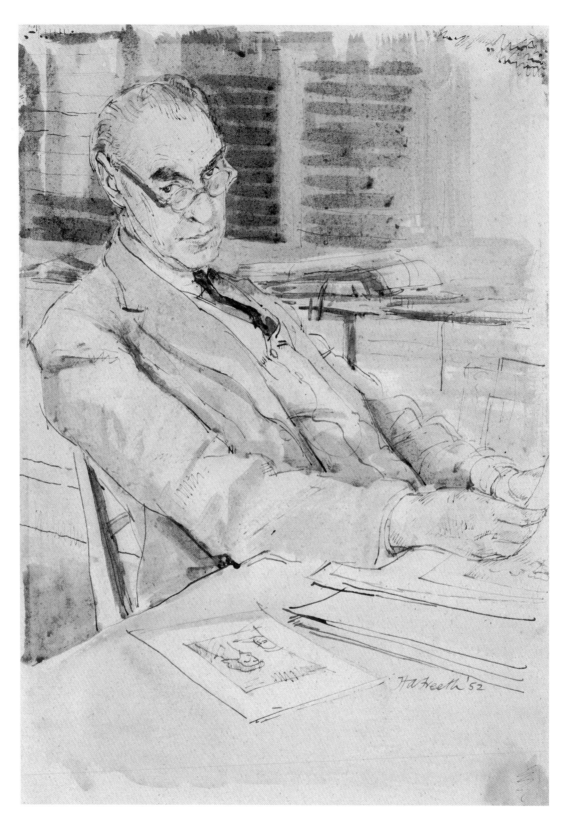

[Fig.9] Hubert Andrew Freeth (1912–1986), *Portrait of Sir Karl Theodore Parker* CBE
(Keeper of the Department of Western Art 1934–1962), 1952, pen and red ink, with watercolour, 45.4 × 31.7 cm,
Ashmolean Museum, University of Oxford, WA1968.461, © Martin, Tony and Richard Freeth

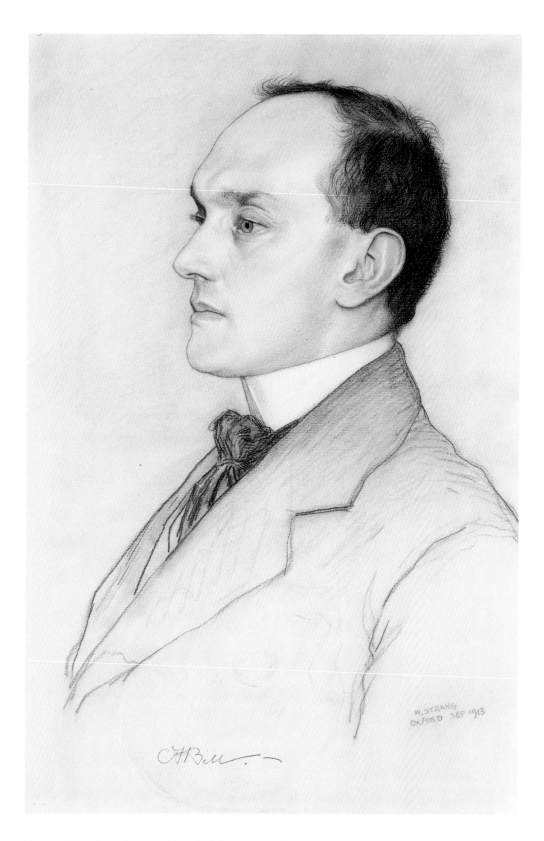

[Fig.10] William Strang (1859–1921), *Portrait of Charles Francis Bell*, 1913,
three coloured crayons on a pale ochre preparation, 41.6 × 26.8 cm, Ashmolean Museum,
University of Oxford, WA1927.19.

for the museum. For many years, he encouraged the numismatist and historian Professor Francis Pierrepont Barnard to think of the Ashmolean as a home for his extensive collection of watercolours. Barnard, who was the great-grandson of the painter Thomas Girtin, presented an initial group of Girtin's work in 1916, and many further works followed in 1934 when his widow relinquished her life interest in the collection.

Bell's successor, his young protégé, Kenneth Clark, was more sympathetic to the moderns. He had become familiar with the world of Old Master drawings while assisting Berenson in Florence during the revision of his catalogue of drawings by Florentine painters. This laid the foundations for Clark's life-long interest in Leonardo. Had he stayed longer than two years at the Ashmolean, he would certainly have left a greater mark upon the prints and drawings collection but the offer of the Directorship of the National Gallery tempted him away and he left the museum in 1933.

The arrival of Karl Parker [fig.9] as Clark's successor as Keeper of the Department of Fine Art at the Ashmolean in 1934, marked the beginning of a heroic period in the history of the Print Room. Parker was a passionate scholar of Old Master drawings and during the twenty-eight years that he spent at the museum, he transformed the somewhat disparate groups which he had inherited into a comprehensive collection of European drawings. He also added the study room where European prints and drawings are now consulted. Work began on the new Print Room in 1939, but the war intervened, the space was requisitioned by the Government and it did not finally open until 1950. Space for drawings had previously been very limited and without the new room, the great expansion of the collection in the 1950s that began almost as soon as it opened would have been impossible.

Parker came to the museum as an established scholar with a wide knowledge of European drawings. He had been awarded his doctorate by the University of Zürich in 1920, had studied German Renaissance drawings in Basel and had worked on the drawings of Watteau as an Assistant in the Print Room of the British Museum. During his long keepership, he transformed the collection with relentless energy and scholarship, adding over 3,000 works covering many aspects of European draughtsmanship, including the work of artists who had been previously unrepresented. Among these additions were a number of major drawings by artists of the French school – Watteau, Boucher, Ingres and Degas [cats. 35–7, 40 and 60] — outstanding works by Rembrandt and the celebrated series of Shoreham drawings by Samuel Palmer [fig.11]. But his chief triumph was the creation of a collection of works by Italian artists from the sixteenth to the eighteenth centuries, and particularly by artists who were then unfashionable, such as Guercino [cat.23] and Carlo Maratta, as well as works by more established favourites such as Canaletto, the Tiepolos [cat.33] and the Guardis. The fact that one third of the drawings in this catalogue were acquired during his keepership indicates the extent of his achievement. Many drawings were bought for sums that now seem absurdly low and many more were received in the form of gifts and bequests as a result of his persuasive efforts.

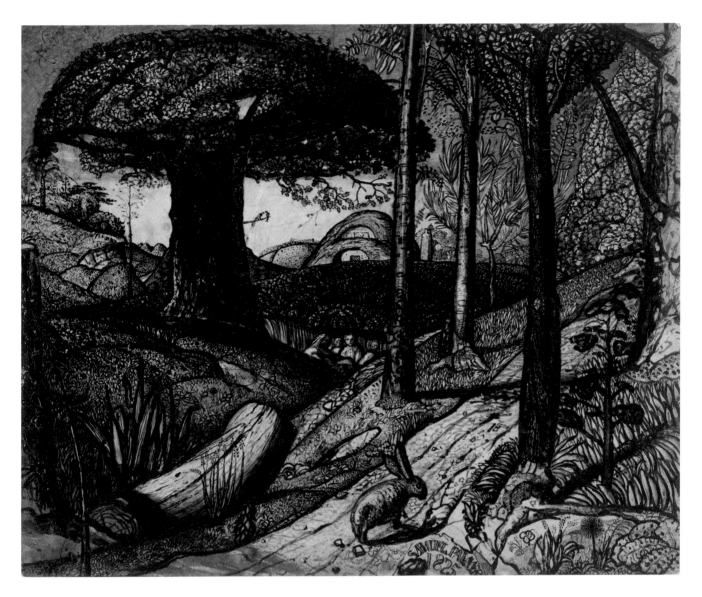

While the works that Parker bought were mainly drawings by the Old Masters, most of the drawings given or bequeathed during Parker's keepership were works of the nineteenth century. Of these, the gift of a collection of works by various members of the Pissarro family was perhaps the most significant in quantity and in the impact it has had on the character of the collection. In addition to an archive of letters written by Camille Pissarro and by his son Lucien, and many more sent to them by friends and contemporaries, the gift brought into the Ashmolean several thousand drawings by Lucien, an archive concerning the Eragny Press, a complete set of Eragny books, a collection of prints by father and son and over 300 of Camille's drawings, constituting the single largest collection of drawings by an Impressionist artist in existence. Esther Pissarro, who made the gift, was Camille's daughter-in-law and had lived with her husband, Lucien, in England since their marriage in 1892. As she had been born in England, and as Lucien had become a naturalised British citizen, she wished to find a museum in Britain as a home for

[Fig.11] Samuel Palmer (1805–1881), *Early Morning*, 1825, pen and dark brown ink with brush in sepia mixed with gum; varnished, 18.8 × 23.2 cm, Ashmolean Museum, University of Oxford, WA1941.107.

the collection. The Ashmolean was not her first choice but it was one of the few museums in the country which could accommodate archives, drawings, prints and paintings within a single collection and could hold out the promise of creating a Pissarro Room dedicated to the Pissarro family gift.

The bequest of Dr Grete Ring in 1954 similarly added a new school of drawings to the collection. There were no nineteenth-century German drawings before the Grete Ring bequest but with its arrival, the Ashmolean became home to the most extensive collection of early nineteenth-century German drawings in the country. Drawings by the so-called Nazarenes, a group of Austrian, German and Swiss artists who went to Rome at the beginning of the century and were an important influence on the Pre-Raphaelites, are particularly well represented along with works by a few of their contemporaries, Caspar David Friedrich [cats. 44 and 45], Anselm Feuerbach, Franz Kobell and others. The bequest also included seventy drawings by nineteenth-century French artists mostly bought by Dr Ring in the 1930s while she was working in the Paul Cassirer Gallery in Berlin. One third of these French drawings are by Ingres, Corot and the young Degas, artists who drew in the same simplified, linear manner as the Nazarenes. The remainder are mostly by later artists, Millet, Cézanne, Renoir, Manet and others whose work was very fashionable in Germany in the 1920s and 30s. Once again, the Ashmolean was not singled out by the donor in preference to other museums. Grete Ring instructed her executors to give the collection to a deserving institution in Switzerland, the Netherlands or England and, knowing that she had visited and admired the new Ashmolean Print Room on a visit in 1951, they offered the collection to Parker.

The Braikevitch collection of Russian art, like the Pissarro and Grete Ring collections, was not originally intended for the Ashmolean. Mikhail Braikevitch, a railway engineer from Odessa who had emigrated to the West, left his collection to the Tate Gallery or failing the Tate, to another English gallery that would agree to put it on permanent exhibition. This condition was a major difficulty because drawings and watercolours are affected by light and cannot be exhibited for anything other than a short period. Parker won the argument by promising a permanent but constantly changing exhibition of a selection of the works in a room named in memory of Braikevitch. In 1949, after nine years of discussion, the drawings were handed over to the Ashmolean, making it the best collection of late nineteenth- and early twentieth-century Russian art of any museum in Britain.

Braikevitch had already formed a similar collection which he left in Russia after the Revolution and this is now in the Museum of Russian Art in Odessa. He acquired the Oxford drawings in Paris and in London when he followed many of his compatriots into exile. The artists whom Braikevitch liked best, Konstantin Somov, Alexander Benois [cat.65] and Léon Bakst [fig.12], were all associated with the World of Art Movement, founded by Benois in St Petersburg, and with Diaghilev's Russian ballet. Unlike Diaghilev, however, Braikevitch was not attracted by the various kinds of modern art that became fashionable during his

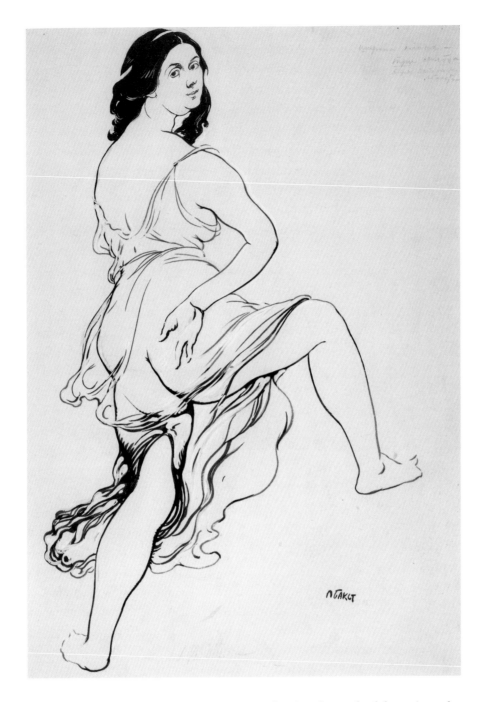

[Fig.12] Léon Bakst (1866–1924), *Portrait of Isadora Duncan Dancing*, *c*.1908, brush and Indian ink over traces of graphite, corrected in white bodycolour on fine-textured off-white paper, 48.9 × 33.3 cm, Ashmolean Museum, University of Oxford, WA1949.321.

years of exile but concentrated instead on collecting the work of the artists who had appealed to him in the years before the Revolution.

Over the years, the collection of Russian drawings has been steadily increased by gifts and bequests. In 1958, the daughters of the Russian artist Leonid Pasternak presented eighteen drawings, watercolours and pastels by their father in memory of the time he had spent in the Ashmolean [fig.13]. A further collection of Russian drawings was bequeathed to the museum in 1960 by David Tobias Gourlande in memory of his wife, Tatiana Gourlande, a doctor who collected Russian drawings, similar in character to Braikevitch's but made by a younger generation. A third

[Fig.13] Leonid Pasternak (1862–1945), *Portrait of Boris Pasternak as a Boy*, 1898, black crayon on off-white paper, 25.4 × 16.1 cm, Ashmolean Museum, University of Oxford, WA1958.19.1.

group was given by Mary Chamot, including works by Larionov and Goncharova, both of whom worked for Diaghilev but were too avant-garde for Braikevitch's taste. Neither the Gourlande nor the Chamot drawings are of the same importance as Braikevitch's but they ideally complement his collection, representing the work of artists who were not collected by him. Single prints and drawings by Russian artists continue to arrive, by gift, bequest or purchase, keeping alive a collection of a kind that is rare in western Europe.

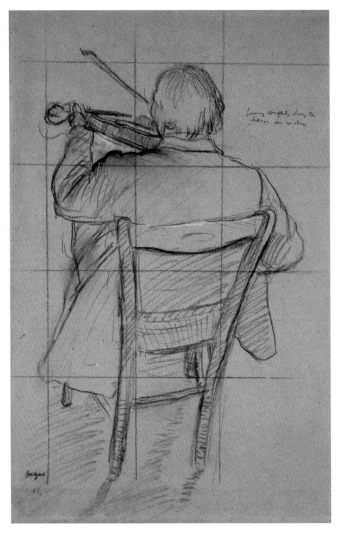

The influx of drawings that marked Parker's years at the museum continued after his departure. The bequest of John Bryson, Fellow and Tutor in English literature at Balliol College, added in 1977 three wonderful drawings by Degas [fig.14] along with a rare academic study of a youth by Cézanne, as well as a collection of Pre-Raphaelite drawings and papers that were a particular scholarly interest of Bryson's. Three years later, the collection of Impressionist drawings was notably enriched by the addition of a small number of drawings of the highest quality which were allocated to the museum in keeping with the wishes of Richard

[Fig.14] Edgar Degas (1834–1917), *Seated Violinist Seen from Behind*, c.1876, black chalk touched with white chalk, squared in black chalk, on grey paper, 48 × 31.5 cm, Ashmolean Museum, Oxford, WA1977.26.

and Sophie Walzer. Mrs Walzer's father, Bruno Cassirer, had been a partner in the picture-dealing firm of Cassirer in Berlin before he set up as a publisher. When he left Berlin for Oxford in the late 1930s, he brought with him an outstanding group of Impressionist drawings, several of which were inherited by his daughter and are now in the Ashmolean.

Drawings of quality are not as easily available as they were in the days of Parker's keepership but they can still be acquired, despite the very high prices which are now attached to the finest works. It is almost paradoxical that as funds are depleted and costs fly upwards, it has become easier to acquire an occasional work of importance and rarity that would have seemed beyond the reach of our predecessors. Since the early 1990s, major works by Rubens [cat.29], Ingres, Samuel Palmer, Guercino, Fragonard [cat.38] and others have come into the collection with essential help from the Heritage Lottery Fund, the Art Fund and through Government schemes to off-set inheritance tax by allocating works of value to public institutions. With help from the Friends of the Ashmolean and from many patrons and donors, the Print Room of the Western Art Department, in common with the museum as a whole, expands and flourishes. There are now over 27,000 drawings and watercolours in the collection extending from the fourteenth century to the present and including works from most European countries. Curators have played their part, but the real creators of the modern Print Room have been the generous collectors and other benefactors whose names are mentioned on many pages of the present catalogue.

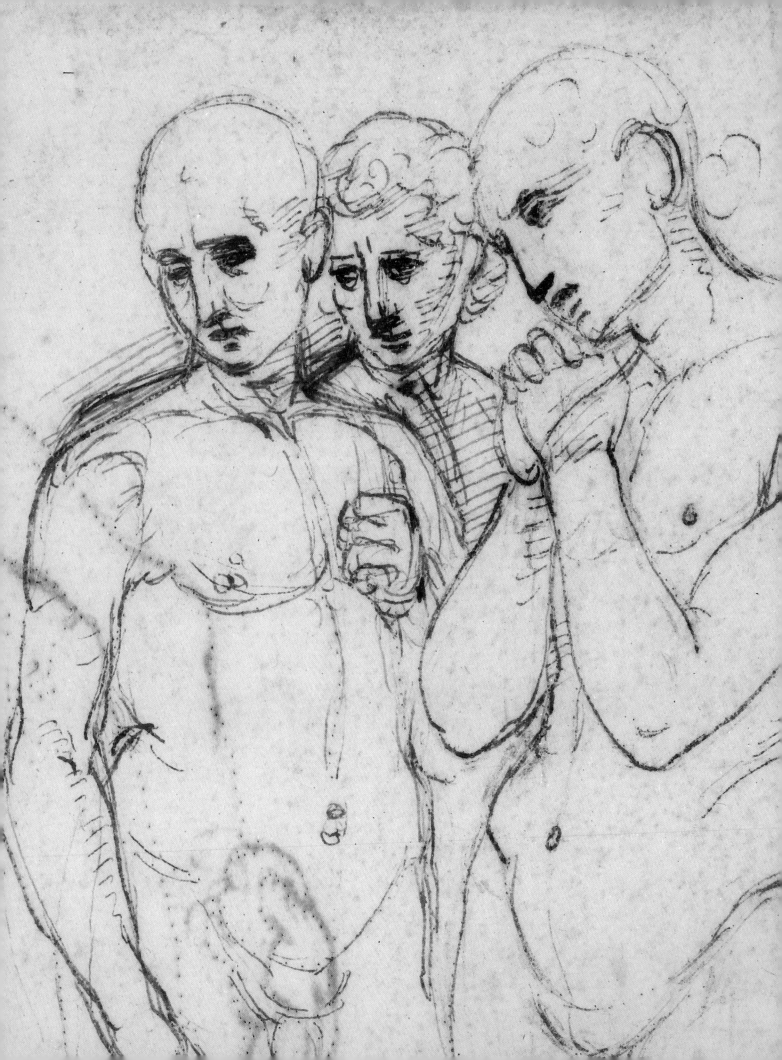

THE MARKS OF THE MASTERS

Materials & Techniques

ARTISTS HAVE ALWAYS ENJOYED EXPERIMENTING AND INVENTING NEW ways of using the tools of their trade. A deeper appreciation of the drawings in this exhibition can be gained if we know what was used to make them. Conversely, the exhibits are in themselves a visual history of the development of paper suitable for drawing on, the use of the metalpoint stylus and the sable brush, responsive pens that did not splatter ink unpredictably, fine quality charcoal and natural chalks, graphite and watercolours.

Raphael (1483–1520), *Study of Four Standing Men in a Pietà* (detail), pen and brown ink with indications in lead point on off-white paper, 32.2 × 19.8 cm, Ashmolean Museum, University of Oxford, WA1846.171.

PAPER

In Western Europe, paper was originally made by hand from shredded linen rag beaten into a liquid pulp. Cotton and hemp were also used. Játiva in Spain was one of the earliest centres of paper manufacture. By the fourteenth century, mills had spread to Italy and then to Germany. The papermaker dipped a grid of wires held in a frame known as a deckle into the pulp, spread it thinly and evenly, then handed it to his assistant, who turned the pulp out onto a bed of felt, and returned the deckle to be reloaded, placing another piece of felt on the wet pulp ready for the next layer. Once complete, the stack of interleaved sheets of pulp and felt was put into a press until dry. The sheets were sized with lime or gelatine to stop them being too absorbent, hot-pressed, then rubbed with pumice stone if an extra smooth surface was required. Paper for printing was sized lightly, as it needed to be slightly absorbent; paper for drawing was sized more heavily.

The horizontal wires in the grid, which were closely spaced, are known as laid lines, and the vertical lines, which were much further apart, are chain lines. The wire grid often had a wire design, either the maker's trademark or an indication of the quality of the paper being made. The thickness of this wire pattern thinned the pulp in that area and so made it more transparent and visible when the paper was finished. This is known as a watermark [fig.15].

At first, scribes and artists regarded paper as a second best to the fine parchment made from unborn calves' skin, known as vellum. Growing sophistication in the use of woodcut blocks of images and words led to increased demand for paper, and improvements in its quality. In the second half of the fifteenth century, the invention and spread of printing using moveable metal type led to the production of paper on an industrial scale, and it steadily became cheaper [fig.16]. By the sixteenth century, paper sizes began to be standardised for use in printing presses, and artists

were using paper more and more to sketch and work out ideas. In Italy the full-scale drawings for frescoes, grand oil paintings and tapestries were known as 'cartone' (cartoons), and were made using several sheets of paper glued together. Venetian artists experimented with coloured papers, ranging through blue and grey to fawn.

[Fig.15] Raphael (1483–1520), *Combat of Nude Men* (detail), red chalk on off-white paper, 37.9 × 28.1 cm, Ashmolean Museum, University of Oxford, WA1846.193.

METALPOINT

Both before and after paper came into general use, a stylus could be used to indent the parchment or paper as a guide before using pen and ink or chalks. Leonardo used a stylus with pen and ink for his *Maiden with a Unicorn* [fig.17, cat.9]. If the stylus was tipped with metal, this left a thin deposit on the prepared surface; when this oxidised, it appeared as a fine line. The metal used affected the final colour of the line. Silver was the most common, but lead, gold and copper were also used. 'You will be glad to have by you a little book of leaves prepared with ground bone, and to note down notions in it with silverpoint', noted Leonardo da Vinci. 'When it is full, keep it to serve your future plans, and take another and carry on with it'. A wash of pigment could be used to strengthen shadows, and white bodycolour to give accents.

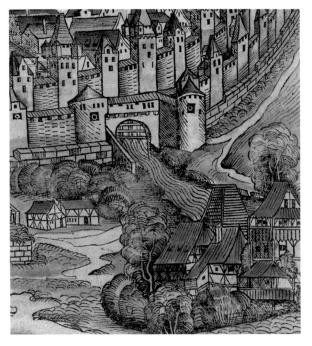

Paper for metalpoint had to be prepared using a finely ground powder made from either lead white, ground bone or ground eggshell. It was then mixed with glue water made from animal glue, preferably derived from rabbit skin, which produced a more flexible glue than that made from larger animal hides. Several layers were usually applied, and could be tinted with pigment as desired. For his *Kneeling Youth*, Raphael used metalpoint on cream prepared paper [fig.18, cat.11].

[Fig.16] Michael Wolgemut (c.1434–1519) and Wilhelm Pleydenwurff (c.1458–1494), detail from Hartmann Schedel's *Nuremberg Chronicle* (1493) showing the Nuremberg Paper Mill, hand-coloured woodcut.

Metalpoint was particularly good for creating a fine line, and as it was not easily erased, it was good training for accurate draughtsmanship. *Il Libro dell'Arte (The Craftman's Handbook)*, a practical guide for artists written by the Italian painter Cennino Cennini in about 1400, provides a wealth of evidence about the purposes

[Fig.17] Leonardo da Vinci (1452–1519), *Maiden with a Unicorn* (detail), cat.9

[Fig.18] Raphael (1483–1520), *A Kneeling Youth* (detail), cat.11

and practices of drawing in the later Middle Ages. Cennini recommends that an apprentice should spend his first year drawing with a silverpoint, touching it with pen and wash when the final image had been fixed, before attempting to work with the pen on its own. An apprentice should be trained to draw by copying the work of his master, though he added that 'the perfect steersman and the best helm you can have lie in the triumphal gateway of copying from nature'. He also had a good deal to say about how students should behave. 'Your life should be arranged just as if you were studying theology or philosophy, or other theories, that is to say, eating and drinking moderately, at least twice a day, electing digestible and wholesome dishes, and light wines; saving and sparing your hand, preserving it from such strains as heaving stones, crowbars, and many other things which are bad for your hand, from giving them a chance to weary it. There is another cause which, if you indulge it, can make your hand so unsteady that it will waver more, and flutter far more, than leaves do in the wind, and this is indulging too much in the company of women.'

CHARCOAL

A more adaptable preparatory medium than the stylus was charcoal, which could be rubbed out using a lump of soft bread or a feather. Popular from ancient times, it can be detected under prehistoric cave paintings, and was used in classical and medieval times both as a guide in large-scale murals and for drawing. Pliny the Elder describes the fourth-century BC painter Apelles of Kos taking a piece of charcoal from the fire and sketching a recognisable face on a wall (*Natural History*, Bk 35). Drawing charcoal is made from twigs from trees with even-textured wood, usually willow. These are heated in a tightly closed vessel, so that oxygen is excluded, until they become carbonised sticks. The slower the burning, the softer the charcoal. It

[Fig.19] Raphael (1483–1520), *Study of Four Standing Men in a Pietà* (detail): see page 26

is greyer than black chalk (see p.34), and particles tend to splinter from the stick, producing an irregular and uneven line. Soaking the charcoal in linseed oil makes the line indelible.

Charcoal was sometimes used in early Northern European drawings, where it is combined with ink, such as Albrecht Dürer's *Portrait of Hans Burgkmair* [fig.5]. It was also widely used for transferring designs to wall or canvas through a technique known as pouncing. Pricks were made in the outline of a drawing, known as a cartoon, then a bag of charcoal dust was pressed against the holes to leave little dots on the surface beneath. Traces of such prickings can be seen in Raphael's *Study of Four Standing Men in a Pietà* [fig.19].

During the sixteenth century, charcoal was largely replaced as a drawing medium by natural chalks, but it became popular again in the nineteenth century, when natural chalk resources were exhausted. Soon it was the most frequently used medium for figure studies and life drawings in art schools. In time, it was valued in its own right by professional artists because of the wide range of effects that could be achieved using different parts of the stick. Edgar Degas drew his *Seated Jockey, Facing Right* [fig.20, cat.63] using charcoal with a few touches of blue pencil on grey paper (now discoloured to brown). Fantin-Latour's *Woman Sewing* [cat.59] is in charcoal, touched with white chalk. In the latter, stumping (using a cylindrical drawing tool made from tightly rolled paper or leather) creates a dense black effect.

[Fig.20] Edgar Degas (1834–1917), *A Seated Jockey, Facing Right* (detail), charcoal, slightly rubbed, with some unrelated touches of blue pencil on grey discoloured paper, 48.0 × 31.0 cm, Ashmolean Museum, University of Oxford, WA1977.27.

[Fig.21] Rembrandt van Rijn (1606–1669), *Jael and Sisera* (detail), reed pen and brush ink, with some corrections in white bodycolour, 17.3 × 25.5 cm, Ashmolean Museum, University of Oxford, WA1950.51.

[Fig.22] Mikhail Fedorovich Larionov (1881–1964), *Woman Walking with a Child* (detail), reed pen and brush in Indian ink on rough grey paper, 32 × 23 cm, University of Oxford, Ashmolean Museum, WA1966.44.10.

PENS AND BRUSHES

Reed pens, made from bamboo or the hollow reeds common to European rivers, had relatively broad nibs, which shed ink quickly and made short lines. Ancient versions can be seen in the Ashmolean's Islamic Middle East Gallery. In medieval Europe, they were mostly used for the large letters and numerical notations in choir books, and rarely for drawings. Later artists experimented. Rembrandt found reed pens effective for heightening drama in such drawings as the hectic and violent *Jael and Sisera* [fig.21]. Other examples of their use in the Ashmolean are Thomas Girtin's *Conway Castle* (WA1934.113, watercolour touched with reed pen over indications of graphite), and Larionov's touching drawing *Woman Walking with a Child* [fig.22].

Quill pens could be made from almost any bird's wing or tail feather, but goose feathers were regarded as the most suitable for writing and drawing. For fine and delicate work, pens were cut from the quills of ravens and crows. They could be cut to a sharper point than reeds, and held more ink. A slit in the nib allowed the ink to flow evenly, and long, elegant strokes could be made. Altering pressure allowed lines to swell or taper. Leonardo da Vinci's *A Maiden with a Unicorn* [cat.9] and Pieter Bruegel's *Temptation of St Anthony* [cat.5] were both made using quills and ink. 'Do you realise what will happen to you if you practise drawing with a pen?' wrote Cennini. 'It will make you expert, skil-

ful, and capable of much drawing out of your own head.' Cennini did not however envisage the degree of improvisation admired by the painter, writer and architect Giorgio Vasari (1511–1574) a hundred and fifty years later. Vasari, an avid collector of drawings, admired originality. In his *Lives of the Artists* he wrote:

Sketches … are in artists' language a sort of first drawing made to find out the manner of a pose, and the first composition of the work. They are made in the form of a blotch and are put down by us only as a rough draft of the whole. Out of the artist's impetuous mood, they

are hastily thrown off, with pen or other drawing instrument or with charcoal, only to test the spirit of that which occurs to him, and for this reason we call them sketches. From these come afterwards the drawings executed in a more finished manner, in the doing of which the artist tries with all possible diligence to copy from the life, if he does not feel strong enough to be able to produce them from his own knowledge. Later on, having measured them with the compasses or by the eye, he enlarges from a small to a larger size according to the work in hand.

Metal dip pens were in use in Roman times, but as they were stiff and were easily corroded by ink, they were unreliable tools until a steel nib with an elongated point was invented by the Sheffield cutler Joseph Gillott (1799–1873) in the 1830s. By the 1850s, more than half the steel pens sold globally were made in Gillott's Birmingham works; it still makes fine-point drawing and mapping pens today. Fountain, or reservoir pens, were known as early as the tenth century, and survive from the eighteenth century, but it was not until the late nineteenth century that problems of leaking and ineffective filling were overcome by such manufacturers as Waterman and Pelikan, and they could be used for drawing with confidence. Pens can be used to create drawings with a high level of fine detail, as in the case of Millais' illustration *St Agnes Eve* illustrated in *Poems by Alfred Tennyson, D.C.L., Poet Laureate* (London: Edward Moxon, 1857) [fig.23]. Alternatively, pen and ink can produce drawings of great simplicity, as in the wonderfully fluid lines of David Hockney's *Henry Writing* [cat.71].

Brushes were used for inks, as well as for colour washes. Brushes could be made from all kinds of animal hair, but white hog-bristles and tail fur from miniver (stoat) and sable (the Russian and Mongolian marten) were the most highly prized. Considerable skill was required to select suitably tapered hairs, tie them together, and fasten them in a quill of the size required. This in turn was attached to a tapered wooden handle. In the nineteenth century, metal ferrules for holding the hairs were developed. Each hair type had its own characteristics and was matched to the type of paint with which it worked best. Sable brushes are especially good for watercolour painting.

[Fig.23] John Everett Millais (1829–1896), *St Agnes' Eve* (detail), pen and black ink, 9.7 × 7.2 cm, Ashmolean Museum, University of Oxford, WA1958.53.3.

[Fig.24] Giovanni Battista Tiepolo (1696–1770), *The Virgin and Child with the Infant St John* (detail), pen and brown ink with brown wash over black chalk, 19 × 16.1 cm, Ashmolean Museum, University of Oxford, WA1962.17.56.

[Fig.25] Rembrandt van Rijn (1606–1669), *Head Study of an Old Man* (detail), cat.24

INKS

Over the centuries, inks have been made from a variety of minerals and natural plant dyes. Carbon ink was long preferred for drawing because it faded less than other inks. Carbon particles were obtained from the soot of burning wax, oil or resin (lamp black), roasted wine sediment (yeast black), burnt bones (ivory black) or from ground wood charcoal. The soot was mixed to a thick paste with a binding medium such as fish glue or gum arabic (sap from the acacia tree) and pressed into cakes or sticks. A 1531 German recipe ran: 'Take a wax candle, light it and hold under a clean basin until the soot hangs from it, then pour a little warm gum water into it and temper the two together – and then that's an ink' (quoted in Ursula Weekes, *Techniques of Drawing*). Chinese ink was particularly long-lasting because of the strength of the glue used and the fineness of the pigment, to which graphite was added.

In medieval times iron gall ink was commonly used for writing, and often for drawing. Tannic acid from ground gall-nuts (such as oak apples) was mixed with iron sulphate and bound with gum arabic. It looked greyish at first, but darkened to black in a short time. Over the years, it faded to brown. Its extreme acidity sometimes causes damage to the paper when it was used heavily, as the *Virgin and Child* by Tiepolo in the Ashmolean shows [fig.24].

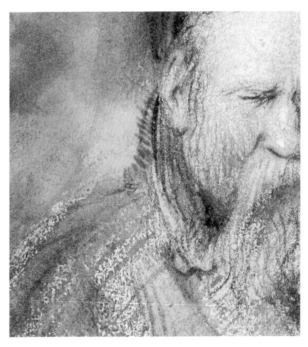

Bistre was a drawing ink made by boiling down wood soot scraped from the inside of chimneys. Soot was ground down, then dissolved in water and strained to remove any coarse grains. Its tarry content meant that no binder was needed. It provided a range of warm colours, varying from pale to dark according to the type of wood burnt. Beech was regarded as best. The rich effect of bistre is shown in Rembrandt van Rijn's drawing of his father Harmen Gerritsz [fig.25, cat.24].

Sepia is often used to describe any brown ink or wash, but real sepia ink comes from the ink sacs of cuttlefish and squid. These were dried, then pounded. The

[Fig.26] Mathis
Nithart Gothart,
called Grünewald
(1480–1528), *An Elderly
Woman with Clasped
Hands* (detail), cat.2

dry colour produced was boiled and strained, then mixed with gum arabic to form cakes. It could be used to draw with, but was usually employed as a wash, as in Caspar David Friedrich's *Landscape with an Obelisk* [cat.45].

[Fig.27] Michelangelo
Buonarroti (1475–1564),
Ideal Head (detail),
cat.18

NATURAL CHALKS, PASTELS AND CRAYONS

From Renaissance times until the nineteenth century, natural chalks were hugely popular drawing tools. Two thirds of the drawings in this exhibition make use of them. They were mined from natural deposits of clay mixed with such pigments as carbon (black chalk), haematite (red chalk), ochre (yellow chalk), umber (brown) or calcite (white chalk). Having been sawn up and cut into shape, they required no further treatment, although they vary in quality. The proportion of clay and pigment had to be correct: too little clay made the chalk crumble; too much meant that it was not dry and powdery enough to draw with. Purity was also important: gritty particles could break the sweep of the draughtsman's line, and scratch the paper. To make chalks easier to handle, they were mounted in holders, sometimes double-ended, with red at one end and black at the other.

Cennino Cennini mentioned deposits of black chalk in Piedmont, and chalk was at first most used in southern Europe. However, the Ashmolean possesses a rare early example of a German black chalk drawing in *An Elderly Woman with Clasped Hands* by Grünewald (c.1470–1528) [fig.26, cat.2]. The heyday of drawing in chalk came with the wide availability of cheap paper. Later writers on artists' materials identified black chalk deposits all over Europe, including Wales and the Hebrides. Black chalk was a broad medium with painterly characteristics, offering a wide range of tone. More permanent than charcoal, it gave a boldness and freedom of line unknown to metalpoint. It was ideal for making large-scale

[Fig.28] Raphael (1483–1520), *Study for a Sibyl* (detail), cat.14

preparatory drawings and cartoons. Raphael's *Study of the Heads and Hands of Two Apostles* [cat.16], a study made at a late stage for his painting of *The Transfiguration*, uses black chalk with white chalk highlights on off-white paper. Towards the end of the eighteenth century, the use of natural black chalk declined as supplies became scarce.

Red chalk, or sanguine, which is iron oxide (haematite) suspended in clay, is harder than black chalk but more brittle. Its translucent beauty made it extremely popular for making detailed, finely worked drawings. One drawing manual described it as 'vivid, responsive … and soft enough to be scratched with a fingernail' (*Mastery of Drawing*, by Joseph Meder). Its tonal range could be increased by wetting, which darkened its effect. Smudging lines with a stump produced a lighter, warmer red. Such effects were due to the flat disc-shape of the haematite particles in red chalk. Leonardo was one of the earliest masters in red chalk, closely followed by Michelangelo who carefully finished drawings he presented to friends, such as his *Ideal Head* [fig.27, cat.18]. Raphael used a stylus, then mainly red and some black chalk on buff paper for his drawing of the *Study for a Sibyl* [fig.28, cat.14], a study made for the fresco that he designed for the Chigi Chapel in the church of Santa Maria del Popolo in Rome.

'I was raised on red chalk', quipped Jean-Auguste-Dominique Ingres, who used it for his first known drawing, a copy of a portrait by his father made at the age of eleven. Red chalk was used for Fragonard's *Landscape with a Bridge* [cat.38] and in Watteau's *Girl Seated with a Book of Music on her Lap* [cat.36], a virtuoso display of the range and vivacity of coloured chalks known as the 'trois crayons' method. Red chalk was in short supply at the end of the eighteenth century, and artificial substitutes had to be used. Natural white chalk (calcite, or soapstone) was used

[Fig.29] Edgar Degas (1834–1917), *Three Studies of a Ballerina* (detail), charcoal rubbed and touched with pink and brown pastels on thin, yellowish, oiled paper, laid down on stiff paper, Ashmolean Museum, University of Oxford, WA1937.23.

[Fig.30] Valentin Serov (1865–1911), *Portrait of Elena Ivanovna Roerich* (detail), cat.66

[Fig.31] Gustave Courbet (1819–1877), *A Young Boy, Seen from Behind, Holding a Basket of Stones* (detail), cat.58

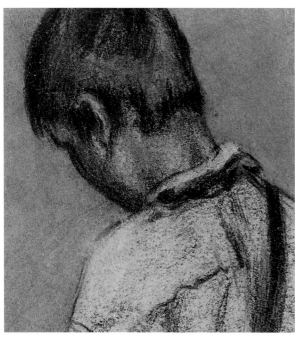

for highlights and accents; it remains plentiful. Brown (umber) and yellow (ochre) chalks were also sometimes used.

Artificial drawing chalks, and the sticks of colour known as pastels, were referred to by Leonardo da Vinci, and he used yellow, brown and pink pastels for his drawing, now in the Louvre, of Isabella d'Este. Early recipes suggest a variety of ingredients and binding mediums (among them fish glue, plant gum, plaster of Paris, milk, beer and honey). The pastel sticks were made softer than chalks, and their colours could be blended by using a stump. One advantage was that mistakes could easily be reworked. Edgar Degas used pastels for his *Three Studies of a Ballerina* [fig.29], as did Walter Sickert in the pastel version of his intensely lively oil painting of the interior of a music hall, *Noctes Ambrosianae* [cat.67]. Valentin Serov's *Portrait of Elena Ivanovna Roerich* [fig.30, cat.66] uses pastel and watercolour with touches of bodycolour on light brown paper. Crayons differed from artificial drawing chalks in being made with oily or waxy substances such as spermaceti (wax from sperm whales and other whales), beeswax and soap. They produced rich colours with an attractive shine. In the early nineteenth century they became useful for the lithographic process. Gustave Courbet's black crayon drawing *A Young Boy, Seen from Behind, Holding a Basket of Stones* [fig.31, cat.58] was published in 1865 in the form of a transfer lithograph known as a gillotage.

GRAPHITE

Graphite is, like charcoal and diamond, a form of carbon. First excavated in early thirteenth-century Bavaria, it was not much used by artists until a huge deposit of exceptionally pure crystalline graphite was discovered above Seathwaite, Borrowdale, in the Lake District of Cumbria, by German miners who had been invited by Queen Elizabeth I to work for the Company of Mines Royal. It was the most profitable substance ever mined in the north-west of England. By the 1660s, it was being extracted on a large scale, used mainly for lining moulds for the

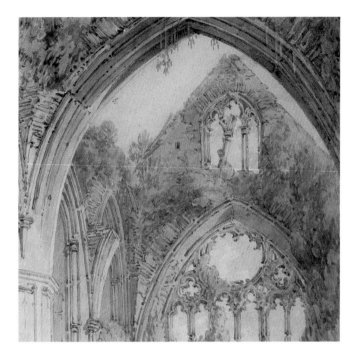

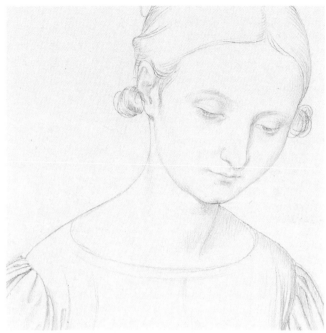

[Fig.32] Joseph Mallord William Turner (1775–1851), *The Transept of Tintern Abbey, Monmouthshire* (detail), cat.49

manufacture of exceptionally smooth cannon balls. Sticks for drawing were first wound with string or sheep's wool, but by the end of the sixteenth century methods of encasing them in wood had been developed. The word 'pencil' originally meant a small brush, but by the seventeenth century it was also being used to describe these wood-encased sticks of graphite. J.M.W. Turner used pencil under pen, black ink and watercolour for his *Transept of Tintern Abbey* [fig.32, cat.49].

The Borrowdale mine was the only European source of pure graphite, so the pencils were known as 'crayons d'Angleterre'. A factory for making Cumberland pencils was established in Keswick in 1832. However, an alternative to using pure graphite was developed during the Napoleonic wars, when France could not import it. Nicolas Conté used milled graphite mixed with china clay and encased with wood to make pencils. These pencils could be of varying degrees of hardness, with soft [B] ones intensely black, and hard [H] ones paler. Harder grade pencils replaced metalpoint, and were welcomed by artists of the Nazarene school such as Johann Overbeck (1789–1869). He used such a pencil in his *Portrait of Nina* [fig.33, cat.42] to create an effect similar to silverpoint. The Conté company diversified to make crayon-pencils in a wide range of colours. In an 1881 letter to his brother, Van Gogh wrote: 'I brought along some conté-crayons in wood (just like pencils) from The Hague, and I work with them a good deal'.

WATERCOLOUR

Watercolour is a transparent medium originally made from finely ground pigments suspended in water and bound with gum arabic, which kept the pigments evenly dispersed and attached them to the drawing support. Watercolour was used to colour Egyptian papyrus rolls, medieval manuscripts and fifteenth-century woodcut

[Fig.33] Johann Friedrich Overbeck (1789–1869), *Portrait of the Artist's Wife, Nina* (detail), cat.42

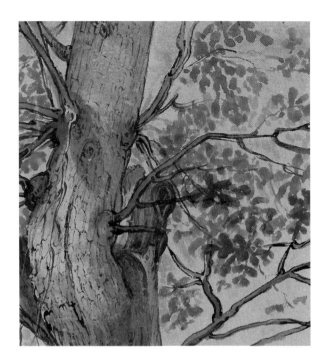

prints. Dürer was the one of earliest artists to regard it as a drawing medium in its own right. He used it for his *View of the Cembra Valley* [cat.1], made as he crossed the Alps either on his way to Italy or on return to Nuremberg around 1494. Holbein's graceful portrait of a *Young Englishwoman* [cat.3] uses pen and ink over a stylus, then watercolour washes. It was also a popular medium for such studies from nature as Hendrick Goltzius's *Study of a Tree* [fig.34, cat.6].

Although many artists used watercolour for preparatory sketches during the next two centuries, the medium was chiefly used for tinting maps and topographical drawings. Towards the end of the eighteenth century, inspired by Edmund Burke's *Philosophical Enquiry into the Origin of Our Ideas of the Sublime and the Beautiful* (1757) and Alexander Cozens's *Essay to Facilitate the Invention of Landskip* (1759), topographical artists became more imaginative and experimental. John Cozens's *Entrance to the Valley of the Grande Chartreuse in Dauphiné* [fig.35, cat.48] uses several layers of wash to give intense depth and texture to the towering crags.

Great skill was required to make watercolour paints until the invention of dry-cake watercolours by William Reeves in the 1770s. He and his brother Thomas founded a family firm in Little Britain, near St Paul's Cathedral, and soon Reeves & Co. were exporting watercolour paint boxes and artists' sundries all over the British Empire. These easily transportable boxed sets made open-air painting much easier. Family tradition has it that a set was sent to St Helena to provide distraction for Napoleon. Experiments first with honey and then with glycerine resulted in the invention of moist watercolours by the painter chemists William Winsor and Henry Newton in 1832. Taking advantage of the newly invented metal tube used by oil painters, they secured a patent to manufacture watercolour paint tubes with a screw cap. Moist paint could produce stronger washes in larger quantities.

The finest brushes for watercolours were made out of Russian sable set in birds'

[Fig.34] Hendrick Goltzius (1558–1617), *Study of a Tree* (detail), cat.6

[Fig.35] John Robert Cozens (1752–1797), *Entrance to the Valley of the Grande Chartreuse in Dauphiné* (detail), cat.48

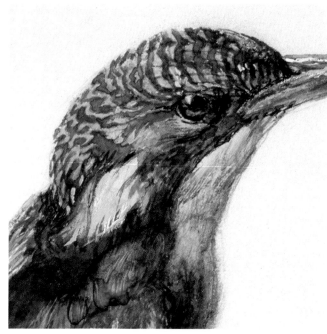

[Fig.36] Joseph Mallord William Turner (1775–1851), *Evening: Cloud on Mount Rigi, Seen from Zug* (detail), cat.51

[Fig.37] Peter Paul Rubens (1577–1640), *Woodland Scene* (detail), cat.31

[Fig.38] John Ruskin (1819–1900), *Study of a Kingfisher* (detail), cat.55

[Fig.39] Gwen John (1876–1939), *A Seated Girl* (detail), cat.69

quills. Winsor & Newton offered them in quills of graded sizes, from crow to swan. Larger brushes were set in metal ferrules with wooden handles. Also crucial to the development of watercolour painting was the invention of fine-textured 'wove' paper by the Kent-based papermaker, James Whatman. These British companies are still in business today.

Renowned as 'the painter of light', the artist J.M.W. Turner made startling experiments with watercolour in his landscapes and seascapes; his *Evening: Cloud on Mount Rigi Seen from Zug* [fig.36, cat.51] is typical of his evanescent and atmospheric later

works. John Ruskin praised the way that Turner expounded the 'higher and deeper truth of mental vision', championing his all but abstract late paintings against contemporary critics. Ruskin encouraged his own followers to make the most of the medium, and his *Kingfisher* [fig.38, cat.55] shows his own mastery of it.

When watercolour is mixed with an opaque substance it is described as bodycolour, or gouache. The early bodycolour known as tempera and widely used in medieval manuscripts was made using egg yolk, with added pigments and such opaque ingredients as white lead, ground eggshells and chalk dust. From the fifteenth century to the present day, fine lines of bodycolour have been used to heighten pen and ink and chalk drawings, for example in Rubens's *Woodland Scene* [fig.37, cat.31] and Gwen John's *Seated Girl* [fig.39, cat.69].

As numerous drawings in the exhibition show, all kinds of effects could be created. Lucas van Leyden put a solid blue background of bodycolour behind his finely hatched chalk drawing of St Jerome [fig.40, cat.4]. Camille Pissarro used gouache for his *Female Peasants Placing Pea-sticks in the Ground* [cat.61]. *Design for the Count's Costume in Act III of The Sleeping Princess* [fig.41], drawn by Léon Bakst for Diaghilev's and Stravinsky's 1921 adaptation of Tchaikovsky's ballet, is made splendidly dramatic by the use of watercolour, bodycolour and gold and silver paint over graphite outlines on cream paper.

[Fig.40] Lucas van Leyden (1489/94–1533), *St Jerome* (detail), cat.4

[Fig.41] Léon Bakst (1866–1924), *Design for the Count's Costume in Act III of 'The Sleeping Princess'* (detail), 1922, watercolour and bodycolour with gold and silver paint over graphite on cream paper, 28.7 × 19.7 cm, Ashmolean Museum, University of Oxford, WA1957.58.

Opposite: Jean-Auguste-Dominique Ingres (1780–1867), *Portrait of Jean-François-Antoine Forest* (detail), cat.40.

This article is much indebted for information to the Ashmolean Museum publication *Techniques of Drawing from the Fifteenth to the Nineteenth Centuries* (1999), by Ursula Weekes, which is available in the Museum Shop. Other sources include *Old Master Prints and Drawings: A Guide to Preservation and Conservation*, by Carlo James *et al* (edited and translated by M.B. Cohn, Amsterdam UP 1997), *The Craft of Old Master Drawings* by James Watrous (Wisconsin, 1957), *Lives of the Painters*, by Giorgio Vasari, translated by G. Bull (Penguin, 1987), and *Mastery of Drawing*, by Joseph Meder, 1919, translated and revised by W. Ames, (New York, 1987. The company histories of Derwent, Reeves and Winsor & Newton and the websites of the Ashmolean Museum, the Tate Gallery and the Courtauld are also helpful sources of information.

1 · View of the Cembra Valley

Brush, watercolour and bodycolour · 21 × 31.2 cm
Presented by Chambers Hall, 1855 · WA1855.99

In the autumn of 1494, Dürer travelled from Nuremberg to Venice, returning to Nuremberg in the spring of 1495. It is generally assumed that this watercolour, one of a series of watercolours that record the route he took across the Alps, was made on this occasion. Although, as he returned to Venice in 1505, this has sometimes been disputed. Whether it was made on his way in 1494 or on his return in 1495 is uncertain as the present watercolour could have been painted either in autumn or in spring. The site, however, has been firmly identified through comparison with a photograph of the Cembra Valley in the North Italian province of Trentino which shows the same view, remarkably unchanged since the time of Dürer.

Watercolour is an ideal medium for a travelling artist as it is portable and easy to use. Colour mixed with water-soluble glue is far easier to carry than other forms of paint and needs no more than a brush, some water and a sheet of paper. Dürer, it seems, was the first of many Northern artists to have used it on his travels. It is uncertain if he invented the topographical watercolour, but no known examples are earlier than this.

The effect of evening light in the sky, now faded, adds a touch of Romantic poetry to the scene. Evening clouds and the setting sun appear elsewhere in his watercolours. No doubt, he was attracted by effects of twilight, although it might also be the case that watercolours like this were made of necessity when he had stopped at the end of a day's travelling and before the onset of night.

2 · An Elderly Woman with Clasped Hands

Black chalk · 37.7 × 23.6 cm
Signed in black chalk: [M]athis, and inscribed by another hand: Matsis; Disses hat Mathis
von / Ossenburg des Churfurst en v[on] / Mentz Moler gemacht / und wo der Mathis ge /
schriben findest das ha[tt] / Er mit Eigener handt gemacht
Bequeathed by Francis Douce, 1834 · WA1863.421

Not only one of the most beautiful studies made by Grünewald, it is also the only
existing drawing which can claim to bear an authentic signature. It is signed by
the artist himself, as specifically stated in the long inscription on the right of the
sheet which also establishes the correct name of the painter. It appears to have been
written by Philipp Uffenbach who, according to Joachim von Sandrart, owned an
album of drawings by Grünewald. This may have passed to Uffenbach from his
master, Hans Grimmer, who was Grünewald's pupil.

Both the type of figure and the nervous, emotive use of black chalk are entirely
characteristic of the small body of drawings by this artist. The play of light over
the face and body is unusually subtle and varied. Although it appears to have
been executed as a study for either the Virgin or the Magdalen in a scene from
the Passion of Christ, the drawing does not connect with any known surviving
work. The drawing can, however, be associated both in theme and in style with
another half-length study of a mourning woman in the Oskar Reinhart Collection,
Winterthur. Grünewald's drawings are very difficult to date but it is generally
assumed that this sheet was drawn shortly before he began work on the major
work of his career, the Isenheim Altarpiece in Colmar, painted c.1512–15.

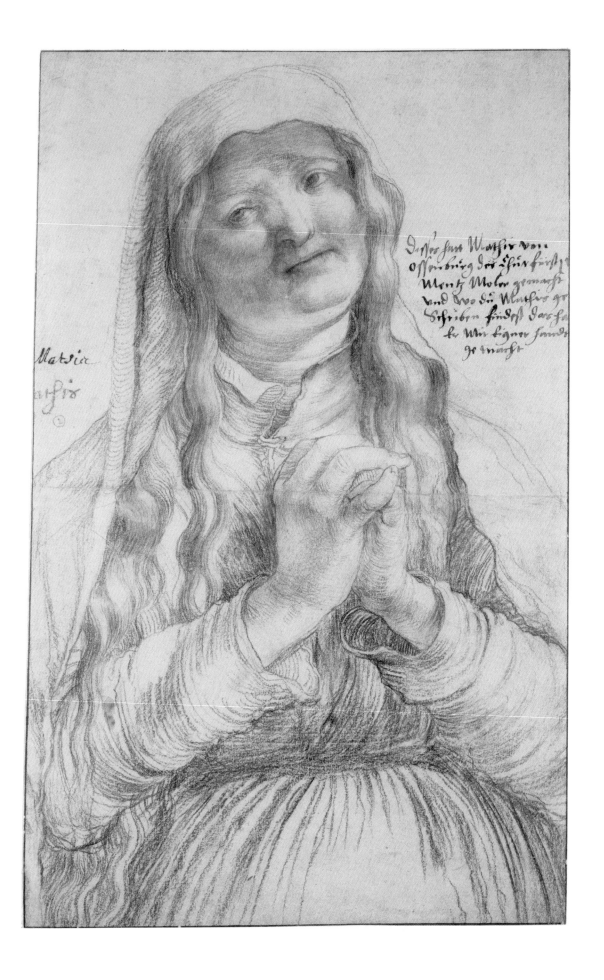

3 · A Young Englishwoman

Tip of the brush with black ink and watercolour,
indented along the outlines with the stylus · 16 × 9.2 cm
Inscribed in ink by a later hand: *H. Holbein*
Bequeathed by Francis Douce, 1834 · WA1863.423

Although engraved in the eighteenth century by Christian von Mechel with the title *A Young Woman of the City of Basel*, it is much more likely that the subject of this famous drawing was an English middle-class woman. What is essentially a costume study is nicely combined with a naturalistic image of a woman lifting her skirt above her ankle. The study was once thought to have been made during Holbein's first stay in England *c.*1526–28 and that the subject was perhaps a member of Thomas More's household, but it is far more probable that it was executed at some time during the second English visit from 1532 to 1543.

The drawing was known to Rembrandt who made a fairly careful copy although he gave the figure a fuller, more characteristic 'Dutch' face. If, as has been surmised, the Holbein drawing actually belonged to Rembrandt, it may have been kept in an album "full of curious miniature drawings...of all kinds of costume" described in the 1656 inventory of his collection. Rembrandt seems to have turned again to this figure as the model for the servant girl on the right side of a drawing of *Lot and his Family Leaving Sodom*, now in the British Museum.

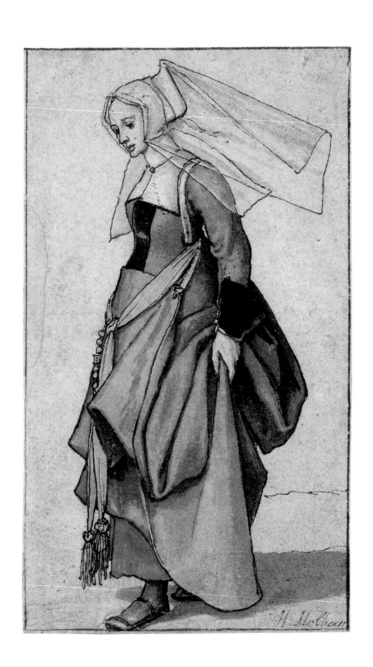

4 · St Jerome

Black chalk with brown and grey washes heightened with white bodycolour
with traces of pen and dark ink and a background of blue bodycolour · 37.6 × 28.1 cm
Signed in lower right with a letter L, cut out and reinserted; dated lower left: 1521; inscribed
in gold, upper left: ST HIERONEMUS: and in lower centre: ALBD
Purchased, 1953 · WA1953.119

St Jerome was a fifth-century Christian priest, theologian and historian, best known
for his translation of the Bible into Latin. Lucas shows the elderly saint, pointing
to a skull, a reminder of mortality, while gazing with solemn intensity towards a
crucifix. In 1520, a year before this drawing was made, Albrecht Dürer had gone
to the Netherlands to renew his Imperial pension. He remained there for twelve
months, meeting fellow artists and making many drawings, including a portrait in
silverpoint of Lucas van Leyden. He also produced a painting of St Jerome, now in
Lisbon, which appears to have been the inspiration for the present drawing and, to
a lesser extent, for another print by Lucas which is also dated 1521. Lucas's image
of the saint is unusually highly finished and was probably created as a work in its
own right and in emulation of the works produced by Dürer during his tour of the
Netherlands. This explains why a later owner added the letters ALBD in gold paint,
in the mistaken belief that the drawing was made by Dürer.

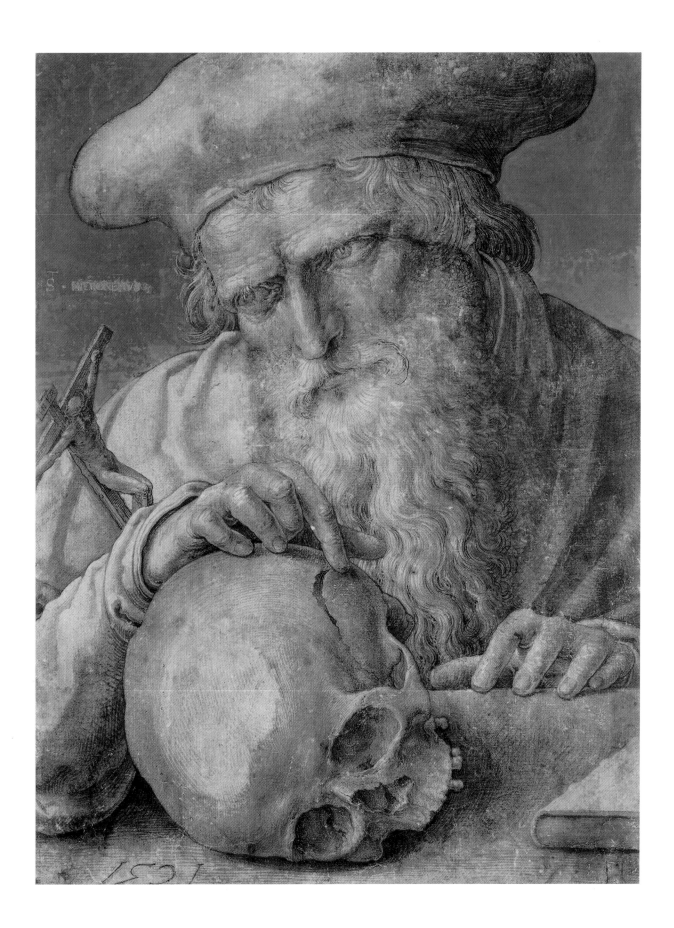

5 · The Temptation of St Anthony

Pen and black ink on discoloured paper · 21.6 × 32.6 cm
Inscribed: *Bruegel 1556*
Bequeathed by Francis Douce, 1834 · WA1863.162

St Anthony the Great was an Egyptian saint who lived in the desert as a hermit for some years. Like other hermits he suffered from hallucinations, which are usually represented in art as temptations, either from an assault by demons or erotic visions. Bruegel's composition, however, includes neither demons nor naked women, and the small money bag (cut from the drawing but visible in a print by Pieter van der Heyden) is the only significant evidence of temptation. The print is inscribed with the title: "Many are the afflictions of the righteous, but the Lord delivereth him out of them all". Bruegel's interpretation of the subject has been much debated but it appears to be concerned principally with the corruption of the Church and the foolishness of the world, on which the kneeling saint has turned his back.

The present study is one of four compositions by Bruegel which were engraved and published by Hieronymus Cock in Antwerp. It does not show as much dependence on the work of Bosch as the other three, although individual details are paralleled in the work of the latter. All show the satirical and moralising aspect of the older artist. Bruegel repeated the motif of the two fantastic figures jousting in a painting of 1559, *The Fight between Carnival and Lent*, now in Vienna.

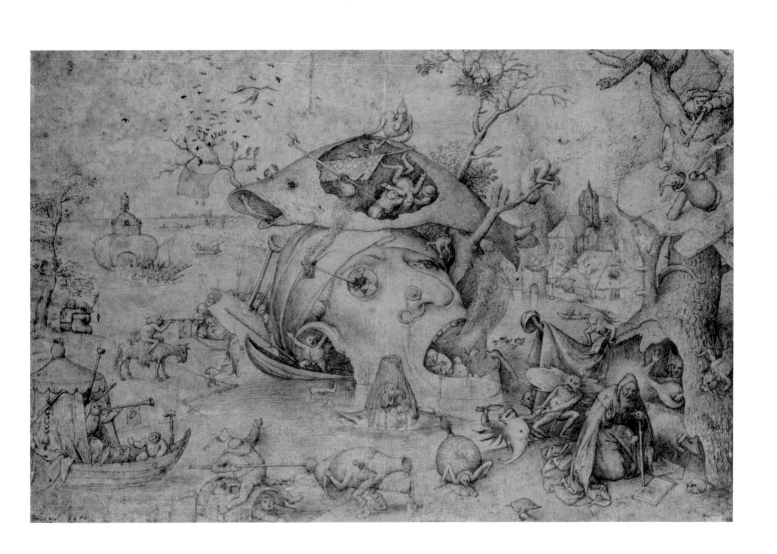

6 · Study of a Tree

Pen and brown ink, brush and watercolour and
bodycolour on blue prepared paper · 42.4 × 30.2 cm
Signed with monogram, lower right: HG
Bequeathed by Francis Falconer Madan, 1962 · WA1962.17.34

This large, beautiful study of a tree was probably drawn about 1600. Clearly done from nature, it was likely executed around the same time and in the same locality as two other studies of trees (now in Hamburg and the Fondation Custodia, Paris) drawn in the district of Haarlem and also executed in coloured washes on blue prepared paper. After the turn of the century, these nature studies led to a more extensive exploration of realistic landscape by Goltzius and other Haarlem artists.

The preoccupation with colour in the various studies of trees foreshadows the artist's interest in taking up painting around 1600. This can be paralleled with other works of the period, most notably the four small undated landscapes in woodcut, printed on blue paper, heightened with white bodycolour in chiaroscuro.

Either a modified version of this study, or other similar studies must have provided the model for the massive tree trunk that appears as the central background feature supporting one or more figures in such works as the highly finished drawing of *Venus, Bacchus, Ceres and Cupid* of 1593 (British Museum) and the engraved portrait of Frederik de Vries of 1597. A similar tree recurs in the background of a very large drawing in Amsterdam, depicting the *Birth of Adonis*, dated 1603.

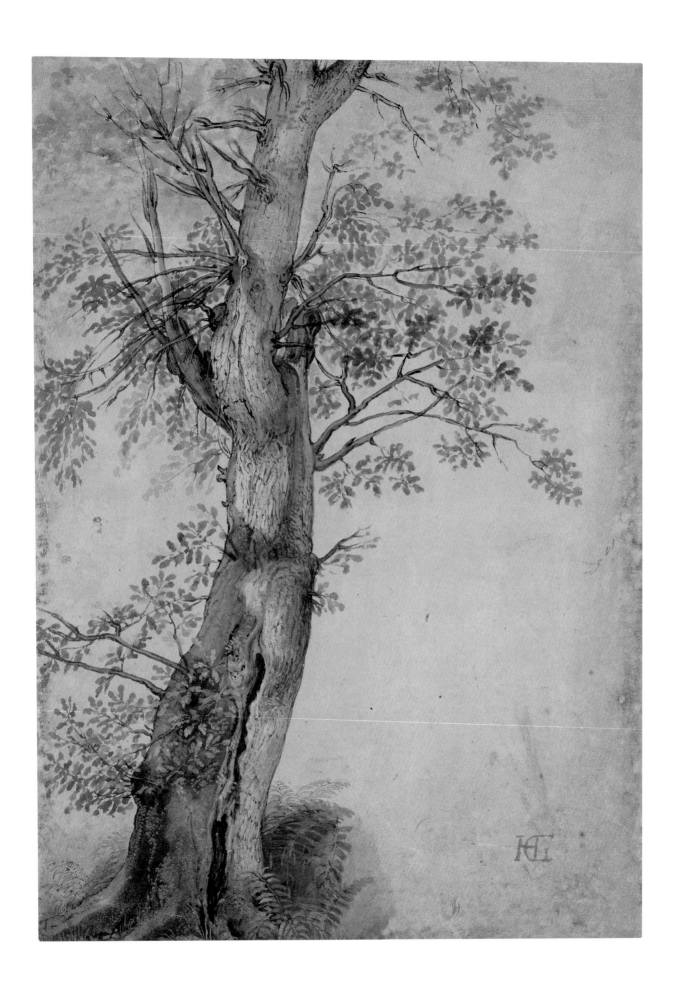

7 · *Head of a Woman in Profile, with a Separate Study of a Pennant*

Black chalk with brown wash, heightened with white on blue-grey paper · 23.8 × 18.4 cm
Accepted by H.M. Government in lieu of Inheritance Tax and allocated to
the Ashmolean Museum, 1977 · WA 1977.17

Blue paper, popular in Venice, was regularly used by Carpaccio in his head and figure studies, and this sheet has retained much of its original freshness of colour. In building up this layered drawing, Carpaccio first used a fine black chalk, then increased the tonal range by the use of thin strokes of brown wash for the hair and shadows on the flesh, and fine touches of white gouache as the figure faces into the light. The dignified, calm expression and the intricate hairstyle are beautifully conveyed in a refined, assured technique. We know more about Carpaccio's style and practice as a draughtsman than we do of his Venetian contemporaries such as Giovanni Bellini, since a variety of his drawings, from compositional sketches to figure studies and workshop copies, have survived. This is one of the most beautiful of his drawings, and is a sheet of considerable importance since a second head study in the same technique is on the reverse.

Both studies were used by Carpaccio for his altarpiece of the *Presentation in the Temple* painted in 1510 for the church of S. Giobbe, Venice, now in the Accademia there. They correspond closely to the heads of the two female attendants of the Virgin Mary. However, the study on the reverse was previously used for one of the saints in the *Glory of St Ursula* altarpiece, also in the Accademia. Given the character of the profile head and the separate study of the pennant (an attribute of a saint), it is quite likely that this too was made in connection with the same altar-piece. The painting accompanied Carpaccio's great narrative cycle for the Scuola di Sant'Orsola, adjacent to SS Giovanni e Paolo. The fact that Carpaccio re-used earlier designs when approaching the new *Presentation* commission speaks of his efficient working methods, where elaborate head or figure studies were kept as an archive of ideas for future reference. Carpaccio's controlled graphic style, his sensitive modelling of form and careful study of the effects of light, illustrate both his interest in naturalism, and his desire to exploit the full potential of his chosen technique.

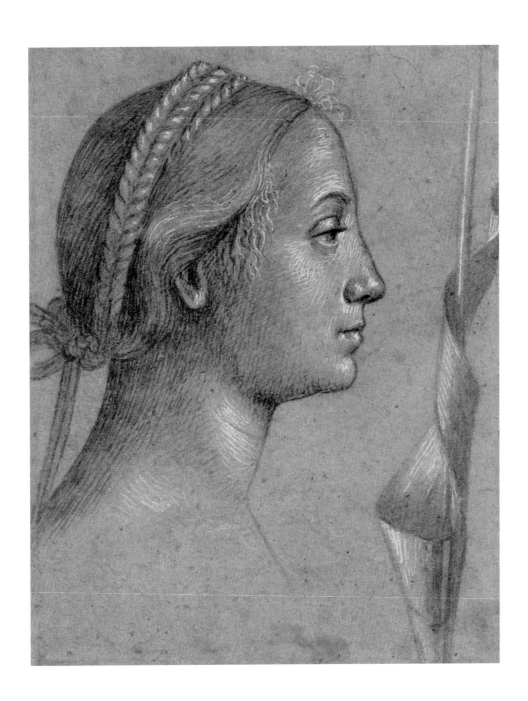

8 · A Horse and Rider Falling

Black chalk with squaring in red chalk on blue paper, faded to grey · 27.4 × 26.2 cm
Presented by Mrs Josiah Gilbert, 1895 · WA1895.6

Titian captures a moment of energetic movement here as the twisting horse falls to the ground, while its rider strains backwards in order to ward off an attack. The black chalk is used with great verve and freedom, with some white highlighting added to sharpen the effect of flexing movement and tension. Some details have been deepened and strengthened with black so as to indicate the overall tonal values of the final work. The sheet of paper is much faded from its original strong blue colour, which would have provided a middle tone. The squaring-up of the drawing suggests that Titian was ready to move on to the next stage of work on a larger scale, possibly on the canvas itself.

The drawing is a preparatory study for a detail in the left foreground of Titian's large *Battle* for the Sala del Maggior Consiglio in the Palazzo Ducale at Venice, commissioned in 1513 but not carried out until mid-1537 to 1538. The picture was destroyed in a disastrous fire of 1577, but its composition is known through painted and engraved copies. There has been much discussion about the subject of the picture; it has been argued that it showed the *Battle of Cadore*, a Venetian victory of 1508, or the more likely alternative, the *Battle of Spoleto* of 1155.

Although the squaring on the drawing might imply that it was the final design, in fact it does not correspond precisely to the relevant detail in the painting. However, Titian's designs did not by any means reach a decisive stage on paper; unlike his Roman or Florentine contemporaries, he often clarified his ideas on the canvas itself, even making radical changes while a painting was well under way. We know of a vigorous compositional drawing for the *Battle*, now in the Musée du Louvre, Paris, where the left foreground includes a horseman charging on a rearing horse. Titian transformed this idea into a skirmish of two horsemen, exploring this revised idea in our drawing. By the time of the painting, he had altered his concept to show instead the rider as a more strongly silhouetted figure, with the horse's head now bowed.

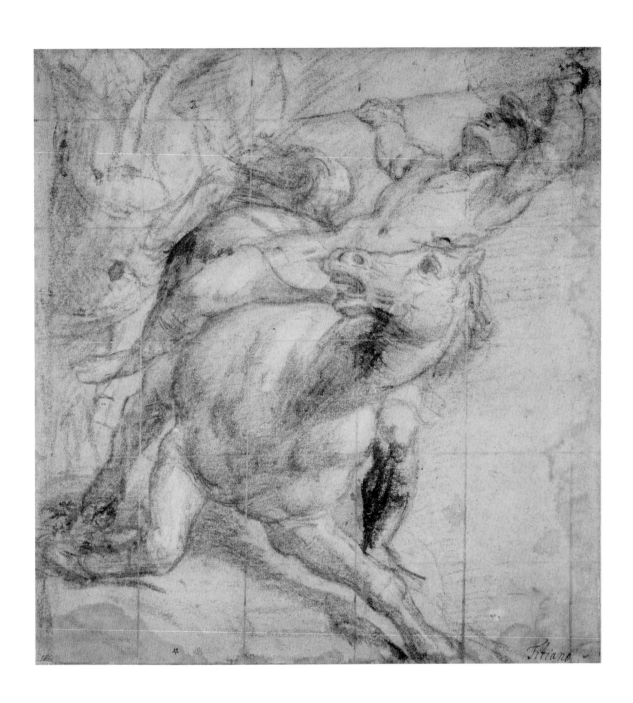

9 · A Maiden with a Unicorn

Pen and dark brown ink over stylus indications on white paper · 9.5 × 7.5 cm
Presented by Chambers Hall, 1855 · WA1855.83.1

Seated in a landscape, a girl looks out at the viewer, proudly indicating a unicorn kneeling beside her with a long rope attached to his collar. The unicorn is in a challenging foreshortened pose, facing the viewer rather than the girl, but with his horn pointing towards her, returning her gesture. Leonardo quickly fixed his composition with some stylus marks on the sheet, worked fluently with pen and ink, using vigorous parallel hatching for shading and fast, rippling strokes for the unicorn's mane and coat. His economical treatment of the plants, tree and sky makes for a breezy, luminous setting. The framing lines in ink are part of the drawing, which has been cut from a larger sheet.

This charming composition reveals Leonardo's poetic imagination, and his fascination with allegories and emblems. According to legend, only a virgin could tame a unicorn, associating this mythical animal with love and chastity. The hunt and capture of the unicorn was a popular subject in medieval art, especially in tapestries. In his own writings Leonardo spoke of the intemperance of the unicorn, whose delight in fair maidens was such that he would forget his wildness and sleep in a maiden's lap, enabling the hunter to take him.

Leonardo explored this subject *c.*1478–81, thinking of ways in which a human figure may be set in relation to an animal whose actions are charged with symbolic meanings. In a sheet of studies in the British Museum, he grappled with the potential of this theme, roughly sketching different possible relationships between the two forms. He continued sketching the girl and unicorn on a different sheet, giving the narrative of this drawing a new clarity. The decisive framing lines signify his satisfaction with this grouping. In courtly portraits an animal may be included so as to provide an insight into the personality of the sitter, as in Leonardo's *Lady with an Ermine* (*Cecilia Gallerani*) in Cracow. This drawing is unlikely to relate to a portrait, and we do not know if Leonardo had a particular project in mind.

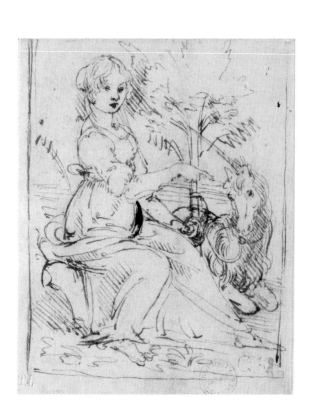

10 · A Unicorn

Pen and dark brown ink with leadpoint on white paper · 9.4 × 8.1 cm
Presented by Chambers Hall, 1855 · WA1855.83.2

An agile unicorn bends to dip his horn in a reflective pool of water. A fragment of another study of a unicorn or a horse, moving to the right, is drawn with a lead stylus, and the sheet has been cut down, probably by an early collector. The unicorn is drawn with marvellous vigour and economy, in a complex pose with the form dramatically silhouetted. The energy and flexibility of the animal's body is sensitively conveyed, yet the strongly hatched pen lines around the form give it the air of a cameo or small relief sculpture. The drawing probably dates from about 1480–82.

Leonardo's interest in unicorns and other mythical animals was fed by his reading of early texts, including the fourth-century Greek *Physiologus*, a collection of moralising and symbolical tales from natural history which he knew in translation. Many traditional symbols with a religious connotation, such as the Pelican, the Phoenix and the Unicorn, owe their origin to the commentaries of early Christian writers on the *Physiologus*, and were taken up in Romanesque and Gothic church decoration, and in other types of medieval art. In a religious context, the unicorn was often associated with Christ, just as the virgin who tames it could be identified with the Virgin Mary. Among the legends associated with this emblematic animal was that of its power to purify poisoned water by making the sign of the Cross with its horn, which is the scene depicted here.

11 · A Kneeling Youth

Metalpoint on cream prepared paper, with unrelated black chalk scribbles · 26.5 × 18.4 cm
Presented by a Body of Subscribers, 1846 · WA1846.153

The kneeling figure looks upwards, hands raised as though in awe, yet he is wearing everyday dress (a tunic, hose and soft shoes). Raphael asked a studio assistant to take up this pose so that he could explore in detail an idea for a figure caught in a visonary moment. He was especially concerned with the foreshortening of the head and with the way in which the figure is caught in strong light falling from the right. The faint indications of voluminous drapery pooling on the ground around the knees and over the feet, together with a swiftly sketched halo, show Raphael thinking ahead to a religious composition.

His chosen technique is metalpoint on paper coated with a gritty layer of ground bone and pigment, where the fine metal stylus will leave an indelible silvery mark. This traditional drawing method, common long before paper was available, was a fundamental part of an artist's training until the early 1500s, leading to a controlled, disciplined approach. Raphael felt completely at home with metalpoint, using it with great refinement and freedom. Here we see him sketching rapidly, defining the contours of the head and hands, changing his mind about the position of the model's foot, thinking of the tonal range in the treatment of shadows, and above all giving the figure an expressive force through the idealised head with upturned eyes and parted lips.

This kind of life drawing was an important part of Raphael's preparatory process, and would be followed by detailed studies of the head and of the drapery. It may be an early idea for the *Mond Crucifixion* (National Gallery, London), an important commission of about 1502–3 for a church in Città di Castello, in Umbria, where the main scene and the narratives beneath feature kneeling figures in poses of adoration or wonder.

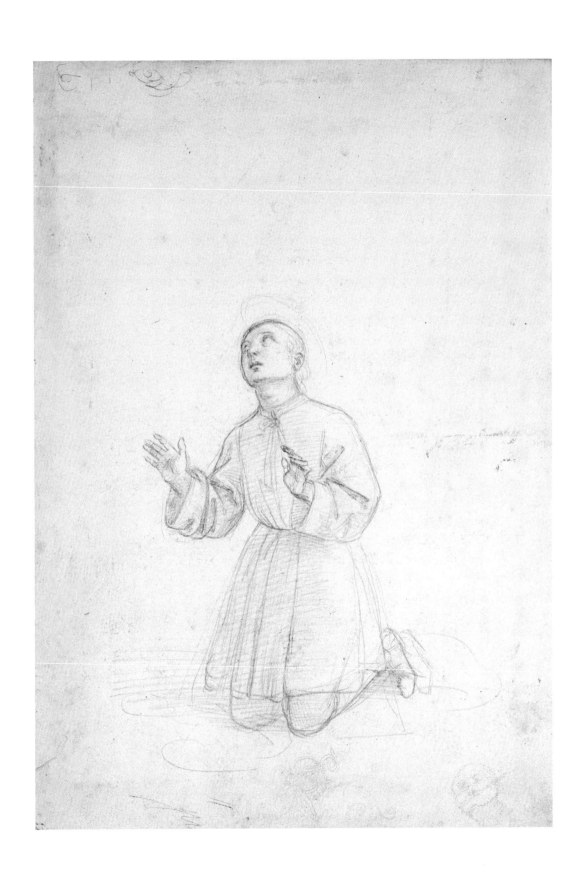

12 · Self-Portrait

Black chalk, heightened with white
on off-white paper · 38.1 × 26.1 cm
Presented by a Body of Subscribers, 1846 · WA1846.158

Raphael used a light, silvery grey chalk to sketch the initial outlines of the face, neck, collar and hat, modifying and filling out the form with more confident strokes as the image took shape on the page. The black chalk is subtly and gently used in modelling the facial features, with some light smudging to soften the effects, while the hair and costume are more broadly treated. Raphael picked out the important elements – the silhouette of the cheek, the line of the upper eyelids, the line of the lips – with a stronger line, deepening the tonal range. He may also have dabbed a little white as highlighting on the tip of the nose and the chin.

The Italian inscription (probably late eighteenth-century) on this drawing identifies it as a self-portrait by Raphael when he was young. We have some good evidence for Raphael's appearance since he painted self-portraits (notably that in the Uffizi, Florence, made about 1506) and he inserted his portrait into the *School of Athens* fresco. The sitter in this drawing certainly resembles the large-eyed, youthful-looking figure seen in these paintings, and Raphael may have portrayed himself here when he was around seventeen or eighteen years of age, about 1500–01.

Some scholars have argued that this cannot be a self-portrait because the sitter seems very young and the style of the drawing suggests a later date of about 1504. However the drawing has many tentative qualities, as in the re-drawing of the contours until a satisfactory sense of volume and proportion was achieved, or the uncertainties in defining the length of the neck and the placing of the collar. Although it is an accomplished drawing, Raphael has not yet found the distilled purity of vision that characterises his head studies towards the end of his Umbrian period in 1504, when he worked on the imposing *Marriage of the Virgin Mary* (Brera, Milan).

Ritratto di se medesimo quando Giovane

13 · The Madonna and Child with the Young St John the Baptist

Pen and brown ink on off-white paper · 23 × 16.3 cm
Presented by a Body of Subscribers, 1846 · WA1846.160

Raphael's career in Florence from 1504–8 saw a number of commissions for devotional paintings of the Madonna and Child, often in a landscape setting. In this rapid, assured pen study, the artist developed his ideas for a large painting c.1506, the *Madonna del Cardellino* (Uffizi) with the figures grouped in a tightly knit pyramidal form in a sparkling landscape. His intention was to show the traditional theme of Mary, the infant Christ and his cousin, the young St John the Baptist, in a fresh light by uniting the sacred figures in a convincing narrative. Raphael knew of the explorations that Leonardo and Michelangelo had made on this theme, and aimed to display his knowledge of contemporary art and his own distinctive qualities of gracefulness and naturalism.

Raphael sketched the protective form of the Madonna in flowing ink lines, using the fall of her drapery to define a backdrop for the interaction of the two small boys. Christ leans back between his mother's knees, balancing one foot on hers while turning to look at the book she holds. The figure of St John has been added experimentally in profile here, drawn quickly over the lines of Mary's arm. Raphael was thinking of the curving and rhythmic shapes created by this figure group, and of the action of the young St John who appears to hold something that has caught Christ's attention. This compositional sketch is part of Raphael's careful design process, and he would further refine his ideas before beginning to paint. The main difference in the painting is that the Madonna's arm is around the young St John, her book transferred to her left arm, and St John, now in movement, holds out a goldfinch which the Child reaches to stroke. Instead of a reading lesson, a much livelier exchange takes place between the two children, with a poignant undercurrent since the goldfinch with its blood-red feathers is a symbol of the Passion of Christ.

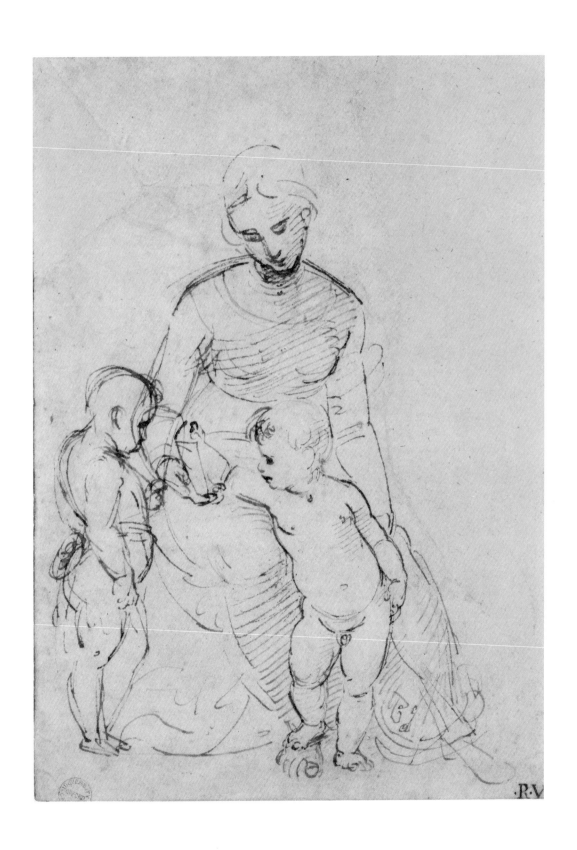

·R·V

14 · Study for a Sibyl

Red chalk over stylus indications with some black chalk on buff paper · 36.3 × 18.9 cm
Presented by a Body of Subscribers, 1846 · WA1846.203

A majestic female figure with a turban-like headdress is clothed in light drapery that swirls in fine folds around her body, as a classical statue. She is identifiable as a Sibyl, a female prophet or seer in the ancient world; Sibyls were renowned for their wisdom and virtue. Michelangelo had depicted Sibyls in the ceiling decoration of the Sistine Chapel in 1508–12, and his representations of these divinely inspired, learned women in complex turning poses with books or scrolls were highly influential.

The powerful papal banker, Agostino Chigi, was one of Raphael's most important patrons in Rome. His chapel in S. Maria della Pace includes fresco decoration with pairs of Sibyls on either side of the arched opening, and pairs of Prophets above. In this preparatory study of about 1511–12, Raphael had to find a convincing way to place the figure in a space defined by the curve of the arch. He sought an elegant, balanced pose that would exude nobility and authority, while also endowing the figure with grace and beauty. Raphael was partly inspired by relief sculpture carved on Roman triumphal arches, where female figures can display complex drapery patterns, however his intention was also to convey a sense of depth and monumentality. This Sibyl becomes an expansive, robust figure as her body moves in space.

Raphael used a metal stylus to make a quick drawing, indicating his idea for the figure, then worked up the drapery and the expressive features in red chalk, modifying and deepening his concept, and taking up some black chalk to make further alterations to the folds. He studied the movement and foreshortening of the Sibyl's bare left arm at the top of the page again. However he was clearly not satisfied with this solution, since the figure was to be considerably changed in the final fresco.

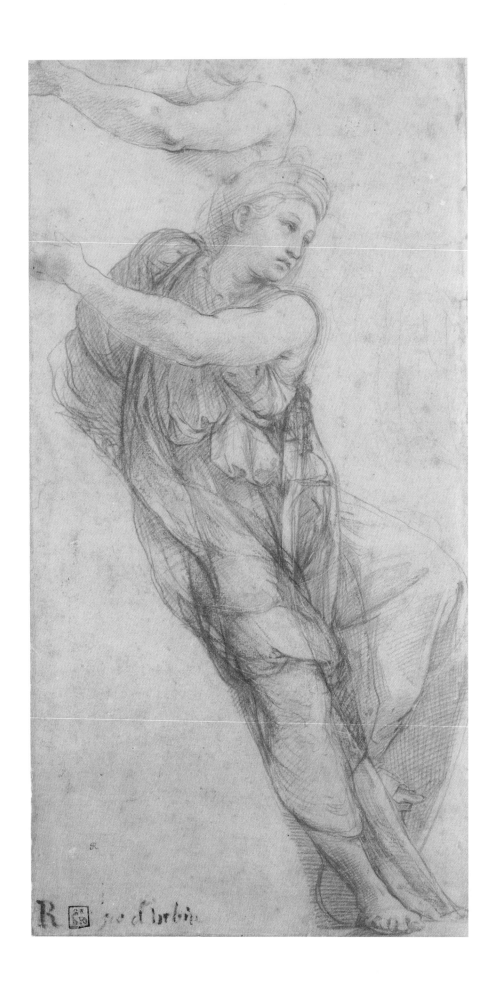

15 · An Angel

Red chalk on off-white paper · 19.7 × 16.8 cm
Presented by a Body of Subscribers, 1846 · WA1846.208

The vitality of this drawing is striking. Raphael was thinking of a boldly gesturing, foreshortened angel, seen from below in strong heavenly light. He used the red chalk economically and swiftly, reinforcing the contours of the arms and making small adjustments as he drew. He was envisaging how folds of drapery would catch the light and define the form beneath, at the same time infusing the figure with grace and benevolence. Raphael may have asked one of his studio assistants to pose for him, although the charming features are idealised. The angel's spreading wings are not studied in detail here, nor is the sphere on which he sits.

The drawing is preparatory for a section of mosaic decoration in the cupola of the Chigi Chapel in Santa Maria del Popolo, Rome. This was an exciting project for Raphael, who designed the architecture and sculptural decoration of the chapel, as well as the magnificent cupola with its rich, antique-style decoration. The commission came from his major patron, the banker Agostino Chigi, who spared no expense on this family chapel, which was to hold the splendid marble tombs of Agostino and his brother Sigismondo. The artist and his patron both died in 1520, with the chapel incomplete (other artists, notably Bernini, later accomplished the project), however the cupola mosaics are dated 1516.

God the Father appears in the centre of the cupola, in the act of creating the universe, which is represented by a series of angels with celestial spheres and stars in compartments ranged around him. Our study of an angel is for a prominent figure with the planet Jupiter, directly beneath God the Father. The figure corresponds quite closely, though in reverse, to the angel in the mosaic who sits on a transparent sphere with both legs visible. Raphael's unusual choice of mosaic – glittering coloured glass pieces backed with gold leaf – gave the ensemble a lavish and brilliant appearance.

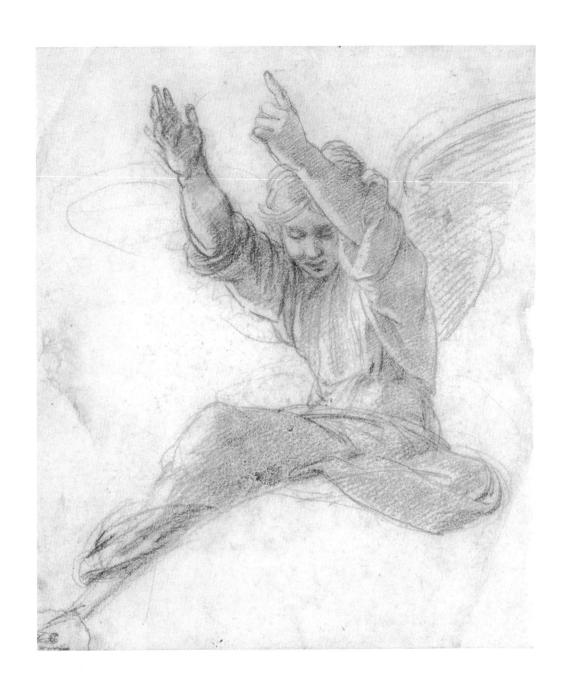

16 · Studies of Two Apostles for the 'Transfiguration'

Black chalk with faint white chalk highlights on off-white paper · 49.9 × 36.4 cm
Presented by a Body of Subscribers, 1846 · WA1846.209

A sublime work of art, this drawing shows Raphael's powers of expression at their height. As a preparatory study for the *Transfiguration* altarpiece in the Vatican of 1518–20, it was made at a late stage in the design process. The reactions and emotions of two contrasting figures, an elderly bearded man and a beautiful youth, are explored with sensitivity and profound insight. Through their eloquent gestures and subtly modelled features, the layers of significance of the dramatic religious narrative can be understood. Raphael's mastery of the tonal range of black chalk meant that he could anticipate the treatment of colour as well as light and shade in the final painting. By this stage, the design had been finalised and a full-size line drawing, a blueprint of the composition, had been prepared. The dotted marks on this sheet reveal that outlines of the heads and hands were transferred from this full-scale drawing, so that Raphael could focus effectively on these crucial elements. He made some slight changes to his design (visible for instance in the positioning of the outspread hands).

In the preceding years to Raphael's sudden death in 1520, he was laden with commissions and prestigious duties, including being architect for St Peter's. His highly trained assistants collaborated with him on altarpieces and fresco decoration. Nevertheless he gave detailed attention to the *Transfiguration*, a monumental painting commissioned by the pope's cousin, Cardinal Giulio de'Medici, which was probably just completed by the time of his death. Raphael's great rival, Michelangelo, had supplied drawings to Sebastiano del Piombo for a companion altarpiece for the same patron, the *Resurrection of Lazarus* (National Gallery, London) so Raphael had to produce a sensational work of art in response to this challenge.

We can trace his ideas in a series of drawings, as he moved towards compositional and theological complexity. In a dramatic interpretation of the *Transfiguration*, Raphael depicted the visionary moment of Christ as Saviour enveloped in heavenly light, while in a rugged, shadowy landscape below, his Apostles fruitlessly attempt a miracle of healing. His success in depicting conflicting emotions relied on the subtleties of characterisation and expression achieved in drawings such as this one. Raphael's expressive heads became models for study in academies of art through the nineteenth century.

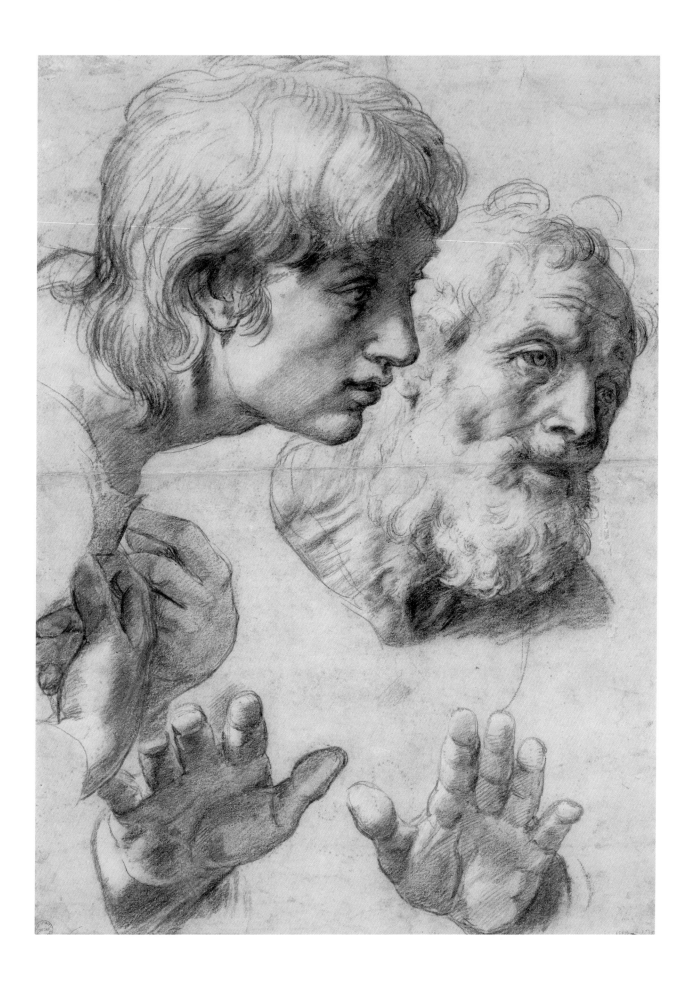

17 · Studies for the Sistine Ceiling and the Tomb of Pope Julius II

Red chalk with pen and brownish ink on off-white paper · 28.6 × 19.4 cm
Presented by a Body of Subscribers, 1846 · WA1846.43

Michelangelo drew the red chalk figure and hand studies first and then filled the blank spaces on the sheet with pen and ink sketches, turning the sheet around to draw the architectural element we see at the top. With many projects simultaneously in hand, Michelangelo's mind was teeming with ideas, and the different studies on this sheet refer to projects in painting, sculpture and architecture.

The red chalk studies relate to the Sistine Chapel ceiling, painted in fresco between 1508–12: the principal study is the figure of a boy who points towards the Libyan Sibyl, and the second study is the Sibyl's right hand holding an open book. Michelangelo worked on this part of the ceiling in 1511–12. The orange-red chalk is especially suited to conveying the warmth and softness of flesh, and Michelangelo used it extensively for life studies for the Sistine frescoes. He lightly sketched the boy's head, extending and defining his initial sketch with sharper contour lines. With a variety of strokes and some gentle rubbing of the chalk, Michelangelo defined the musculature and the effects of light and shade as the boy turns to a companion holding a scroll under his arm. At this point, the artist was typically not concerned with the boy's hair or with details of drapery or accessories.

The pen and ink figure studies are rapid linear sketches for six twisting male figures, some with their arms bound. These show Michelangelo dynamically developing his ideas for the bound captives that he envisaged for the lower storey of the monumental tomb of Pope Julius II. This was commissioned in 1505, but interrupted until 1513. The pen lines are extremely assured, with no alterations in these complex poses. Rather than being his first thoughts, these sketches represent Michelangelo's more considered exploration of designs for the sculptures, with agile, energetic movements and poses captured on this small scale with great panache. The richly ornamented, elegant cornice is beautifully drawn, probably with the architectural structure of the great tomb in mind. Like the pen sketches, this was probably drawn in 1512–13.

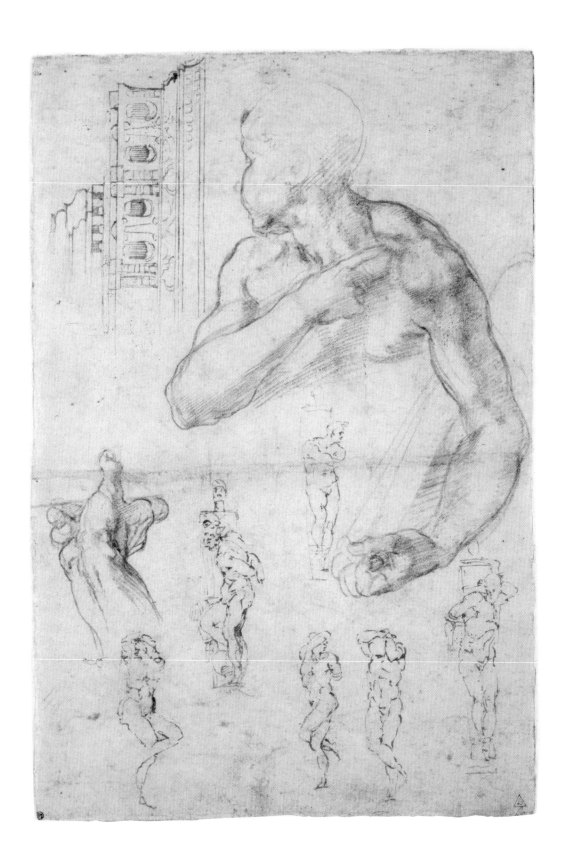

18 · Ideal Head

Red chalk on off-white paper · 20.5 × 16.5 cm
Presented by a Body of Subscribers, 1846 · WA1846.61

Michelangelo used a warm-toned red chalk for this haunting drawing, which he made as an independent work of art in the 1520s. He first sketched the head and shoulders lightly and quite freely, then gently modelled the head and neck with fine strokes and soft touches, rubbing the earthy red chalk in parts to achieve more subtle effects. The sheer mastery and finesse of his technique is seen especially in the delicate rendering of the eyelashes. Michelangelo left parts of the image in a sketchy state, using some fast diagonal hatching to indicate texture and patterns of light and shade. His focus is very much on the structure and expressiveness of the head, seen silhouetted on the white paper, while the details of clothing are barely indicated.

Is the figure male or female? Michelangelo was certainly exploring concepts of beauty and nobility, revealing how the artist could create, out of lines and strokes of chalk, a compelling presence with an air of grandeur and mystery. Although a heavy earring is prominent, the figure has short hair and wears an elaborate helmet-like headdress with flaps and ornamental details; we see the square-cut costume from behind, with a band or decorative element falling from the helmet. Perhaps Michelangelo wished to evoke an exotic, youthful hero such as Alexander the Great, turning in an abstracted way while brooding on his deeds and ambitions. Or, as different scholars have suggested, the drawing may be a study of refined melancholy, whether of a male or female temperament.

We know from early accounts that Michelangelo made finished drawings as presents for intimate friends that were known as 'teste divine', divine heads, because of their rare beauty. Such gifts were highly prized as testimonies of love and friendship, and as extraordinary works of art by an artist who was also a poet.

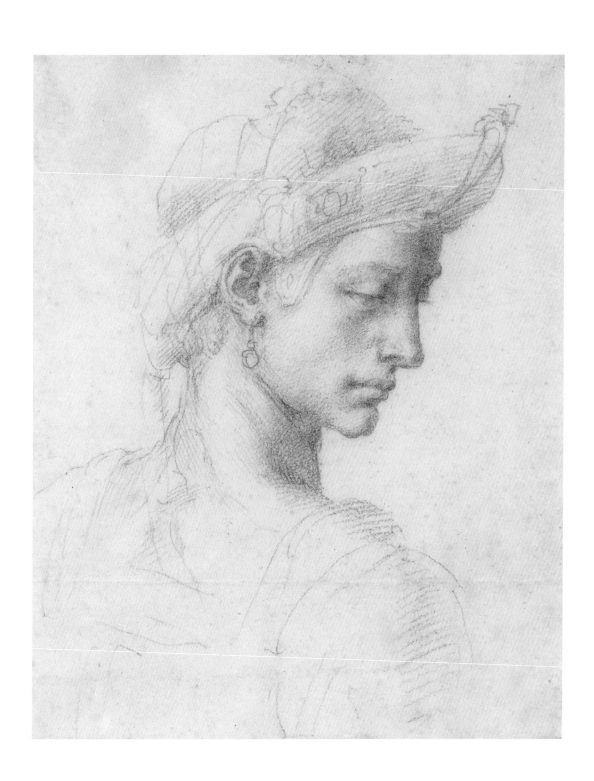

19 · Samson and Delilah

Red chalk with some stylus indentation on off-white paper · 27.2 × 39.5 cm
Presented by a Body of Subscribers, 1846 · WA1846.65

A nude muscular man, a giant compared with the female nude who turns away with a gesture of triumph, seems unable to raise himself from the ground. A key moment of tormented recognition is represented here, part of the story of the biblical hero Samson who lost his strength when Delilah cut his hair, so that the Philistines were able to take him prisoner.

The red chalk is worked with astonishing finesse and elaboration, as Michelangelo built up the hulking form of Samson and the play of light on his skin with a mesh of loops and curling strokes. Some areas of the drawing are treated lightly and left unfinished, especially Delilah's head and right arm, and delicate shading contrasts with darker hatching or with the sharp delineation of contours. Michelangelo's focus is mainly on Samson and the ebbing away of strength from his powerful body, with Delilah as a lithe, agile, almost weightless figure.

The drawing seems likely to have been made as an independent work of art, around 1530. The subject of Samson and Delilah is open to different interpretations, with its themes of love and betrayal, or loss of vitality after sensual indulgence, or the hero confronting his destiny (since the captive Samson was to kill himself and the Philistines). Michelangelo made highly worked drawings as gifts for his intimate friends, often of poetic or enigmatic themes that can have an allegorical meaning. These narrative scenes were drawn with immense skill and thoughtfulness, and his friends perused them carefully, admiring their virtuosity and teasing out their significance. Like Michelangelo's poetry, the drawings were intended to demonstrate his creative imagination and his capacity to convey ideas and emotions in beautifully realised forms.

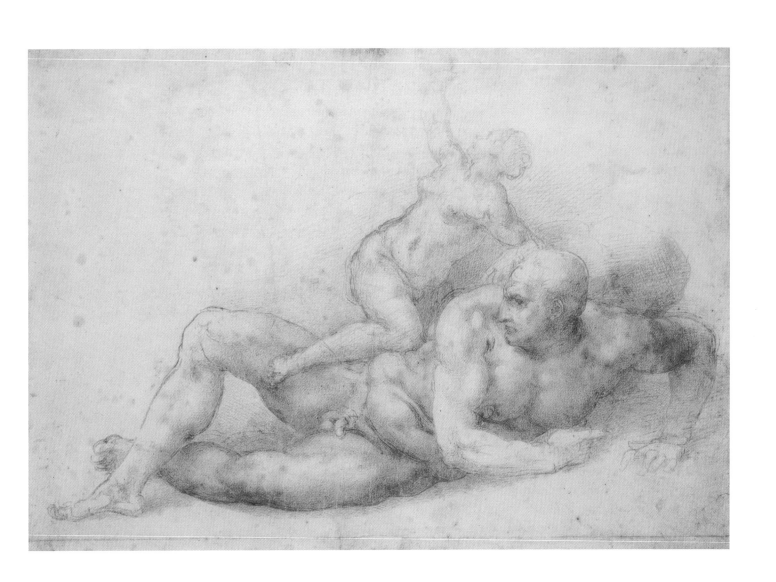

20 · The Risen Christ Appearing to his Mother

Black chalk on off-white paper · 22.1 × 20 cm
Presented by a Body of Subscribers, 1846 · WA1846.91

Drawn late in Michelangelo's life, about 1555–60, this moving image may have had a private significance for the artist. The seated Madonna is surprised by an apparition, as Christ floats before her in his funeral shroud, showing the wounds of the Crucifixion. This unorthodox subject was popular in medieval art, especially in the north of Europe, although it is not in the Gospel accounts. In being visited by her son who has risen from the dead on Easter morning, Mary becomes the first witness to the Resurrection. Christ's appearance finds a parallel with another popular subject in art, that of his farewell to his mother when leaving home to fulfil his earthly mission. Michelangelo also worked on this subject late in his career. Here the composition, and the figure type and costume of the Madonna, recall his explorations of the theme of the Annunciation around ten years earlier. Appropriately, this visionary scene of Christ's last farewell mirrors in design and significance the Annunciation, where the angel Gabriel tells Mary she will be the mother of the Saviour.

Michelangelo uses the black chalk with extraordinary freedom, conjuring up the spectral form of Christ with a film of silvery-grey, tremulous lines. Worked with stronger, darker strokes, Mary is a more solid, sculptural figure, who takes shape out of many revisions as the artist reconsiders the position of her head or her legs. She reaches out to her son but the gap between their hands recalls the Gospel narrative of the risen Christ meeting Mary Magdalen, who may not touch him ('noli me tangere'). The sensitive and poignant treatment of the mother in this moment of final farewell, and the intensity and dignity infusing the ghostly figure of Christ, give this drawing a sense of fervent spirituality. Michelangelo wrote anguished poetry on religious themes and some of his late drawings similarly seem to function as lingering meditations.

The inscription on the drawing shows Michelangelo thinking about Cornelia, the widow of his servant and friend Urbino, who had returned to her native Casteldurante after her husband's death. He had provided designs for paintings of a *Crucifixion* and an *Annunciation* which were intended for her husband as mementoes for their sons, but the paintings had gone to the Duke of Urbino, and in 1557 Cornelia hoped to obtain replicas of them. Possibly this triggered Michelangelo's contemplation of related religious themes.

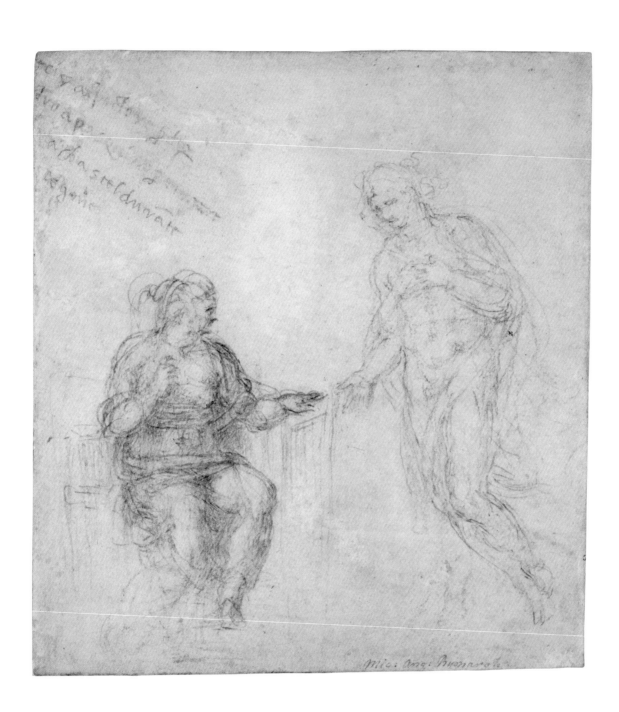

21 · Study of a Boy in Movement

Red chalk, heightened with white, on buff paper · 27.7 × 19.2 cm
Purchased, 1940 · WA1940.43

A smiling, half-draped boy holds an ambiguous pose in this life drawing. He seems to be in motion, stepping up or down, while the way in which his chest muscles are tensed, together with the position of the hands, suggest that he is carrying an object, possibly concealed in the folds of the drapery. In fact, Annibale made use of this beautifully executed study in his preparation for two different commissions of the 1580s.

The boy appears, fully dressed, in the left foreground of the fresco *The Infant Jason Carried in a Coffin to Chiron's Cave* in the Palazzo Fava, Bologna. This was part of an important narrative cycle carried out as a collaborative effort by the Carracci work-shop – Annibale, his brother Agostino and their cousin Ludovico worked closely together at this time. The pose and expression of the boy in this fresco of 1584 are very similar to this drawing, the principal change being in the angle of his arms, as he now holds a tall jug to his chest. The boy's appealing glance over his shoulder, and the curving fall of drapery from hip to knee as he walks, are directly transposed from the drawing. Annibale allowed for the fact that the light falls from the left in the fresco, adding some delicate touches of white on the drapery.

At the same time, Annibale was preparing for a major altarpiece, commissioned in October 1583, the *Baptism of Christ* in S. Gregorio, Bologna, completed in 1585. On the left in that painting, a young man is shown undressing, and the artist tried out a pose of a kneeling youth pulling up his shirt with both hands in a life drawing now in Paris. For the final painting, Annibale moved towards a more complex pose based on the figure in our drawing but seen from another angle.

22 · The Birth of the Virgin Mary

Black chalk with pen and brown ink and grey wash, heightened with white on pale buff
paper, indented for transfer and squared in black chalk · 35.6 × 56.7 cm
Purchased with the help of the Art Fund, the Friends of the Ashmolean Museum, the
Pilgrim Trust, the William A. Cadbury Charitable Trust, 1972 · WA1972.130

Ludovico drew this elegant, balanced composition of nine figures in preparation
for a painting of *c.*1591 traditionally called the *Birth of St John the Baptist*, but almost
certainly depicting *The Birth of the Virgin Mary*. This was painted for the Bonfiglioli
family in Bologna, but the picture left Italy in early 1770 when Gavin Hamilton
acquired it for John Fitzpatrick (1745–1818), second Earl of Upper Ossory. Hamilton
had the painting engraved by Domenico Cunego in 1769 for his illustrated volume,
Schola Italica Picturae (Rome, 1773). Ludovico Carracci and his cousins Annibale and
Agostino were hugely influential artists, and at this time they were household
names in Britain.

Ludovico was concerned with establishing the rhythm of the figure groups, and
their actions and expressions. The women are midwives, servants or visitors, and
the only male figure is the elderly father, Joachim, who kneels to give thanks on the
right. Ludovico used black chalk first (and various alterations can be seen, especially
in the figure of the woman holding up the basin), then fixed the main lines of his
design with pen, ink and wash. He then squared up the composition for transfer to
a larger scale. In the final painting, the figures were placed in an echoing interior
setting with the Virgin's mother St Anne visible through a doorway in the distance,
but the essentials of the figure group here remained. However, the young girl who
forms a graceful link between the two main groups was omitted at a late stage.
Ludovico had some difficulty with the figure of the elderly woman on the right,
who reaches to take hold of the newborn child, since he cut out and patched in a
revised design. This solution did not satisfy him, and instead in the painting the
woman gazes at the baby, her hands outspread in wonder.

23 · The Mystic Marriage of St Catherine

Pen and brown ink with brown wash
over indications in black chalk on white paper · 25.6 × 20.3 cm
Purchased, 1939 · WA1939.66

St Catherine of Alexandria (identified by her crown) is about to receive a wedding ring, signifying her close spiritual relationship with Christ, who is shown as a tender child balancing against his mother's arm. The Madonna delicately takes St Catherine's hand, while her son holds a ring in readiness. Guercino lavishly used the pen loaded with ink, working with diluted ink washes to create a powerful sense of presence and a range of emotion. The washes are delicately brushed over the sheet, modelling the forms and suggesting warmth and intimacy. The white paper seems infused with light. A swift pen stroke across the bottom suggests a framing element, signifying Guercino's satisfaction with this composition.

This atmospheric drawing relates to a devotional painting of 1620, now in Berlin. This was made for the Cavaliere Piombino, a patron in Guercino's native Cento, near Ferrara. In the painting, the forms are more tightly entwined and the focus is closer still, so that the figures fill the dramatically lit space, making for an intense image. The drawing was probably preparatory for the painting, although its highly worked character also suggests that it could have been an independent work of art, a variation on this popular devotional theme. Even at this early stage in his career, Guercino's virtuoso use of pen and wash was greatly admired, and he was a leading teacher in Cento. His robust, passionate style at this time was based on his study of the naturalism and expressive qualities of the Carracci in Bologna. However, his sojourn in Rome in 1621–23 had a major impact on his art. He became more measured and classical in his approach, aiming for a sense of grandeur and lucidity. Even though his style of painting changed, an intensity of purpose and a strong emotional charge, so evident in this enchanting study, still permeates his drawings.

Guercino

24 · Head Study of an Old Man

Red and black chalks with brown wash · 19 × 24 cm
Inscribed in pen and black ink, lower centre: HARMAN.GERRITS.van de Rhijn
Presented by Chambers Hall, 1855 · WA1855.11

Rembrandt made many paintings, drawings and etchings of elderly men in Leiden and in his early years in Amsterdam. There is a similarity between the subject of this drawing and a group of paintings of old men with eyes cast down dating from around 1630. It is likely that he used the same model for at least some of these drawings. Several have been identified as portraits of his father, Harmen Gerritsz van Rijn (c.1568–1630), but without much supporting evidence. This study has a better claim than most to be an authentic portrait of Harmen Gerritsz on account of the inscription in a seventeenth-century hand that firmly identifies the sitter. The handwriting is possibly Rembrandt's own, which, if this could be confirmed, would establish the identity of the sitter beyond doubt.

The combination of red and black chalks and brown wash appears often in Rembrandt's early work. The red chalk has been applied here, in parts, with particular haste but the features of the sitter, who appears to be asleep, are touched in with an affectionate attention to detail. If this is a portrait of the artist's father, it must have been drawn before Harmen's death in 1630 when Rembrandt was still based in Leiden.

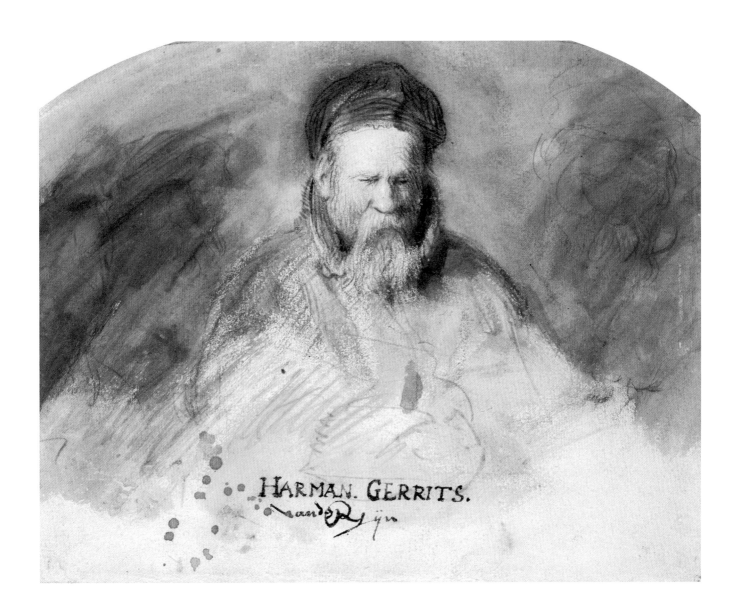

25 · Saskia in Bed

Pen and ink with brush in brown ink · 14.4 × 20.8 cm
Purchased, 1954 · WA1954.141

Drawing for Rembrandt not only had a practical purpose but was an activity which became part of the fabric of his life. His drawing style evolved over the years but it has a distinctive character that remains constant. His pen lines resemble the lines in his etchings, sometimes fluent, sometimes more jagged, while his brushwork is applied with a brilliant spontaneity. He had, however, many pupils, and the distinction between his own drawings and those of his followers is sometimes difficult to pin down. In this case, the breath-taking assurance of the pen work on the figure and the lively brush used in the details of her bed and curtain could not have been the work of any other. The subject of the drawing is Saskia van Uylenburgh, Rembrandt's first wife, whom he married in 1634. She appears in many of his drawings and etchings, often, as here, in an informal moment. In this drawing, she is asleep in bed, possibly during her final illness in 1642. There is an etching of her sleeping in bed, lightly improvised on the copper plate, which is so close in character to the drawing that it must have been made at the same time.

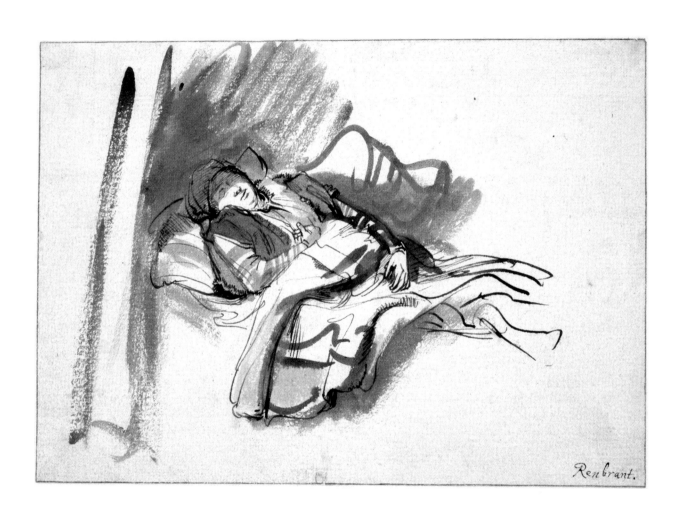

Renbrant.

26 · Rembrandt's Studio with a Nude Model

Pen and brush with brown ink · 20.5 × 19 cm
Presented by Chambers Hall, 1855 · WA1855.8

In 1639 Rembrandt bought a fine three-storey house in Sint Anthonisbreestraat (now the Jodenbreestraat) for the substantial sum of 13,000 guilders. He remained there until 1658 when financial difficulties forced him into bankruptcy. This drawing shows a corner of his studio, located on an upper floor, with his easel on the left and a model, sitting in the daylight, on the right. There is a fireplace with flanking columns behind the model and a table with books or portfolios in front. The rest of the detail is difficult to make out partly because the drawing is chiefly a study of light and shade. The daylight has been partly excluded by the shutters in the lower half of the window, but is reflected down onto the model by the sheet suspended above the upper half. This contrast must have been more striking when the drawing was new but it has been reduced over time with the fading of the ink. It has been suggested that the seated figure is Hendrickje Stoffels, Rembrandt's mistress, who lived with him and his son Titus in the house from 1649. This is possible but unverifiable. The room survives, remarkably similar in appearance to the room in this drawing partly because it has been restored in recent years using this drawing as a model.

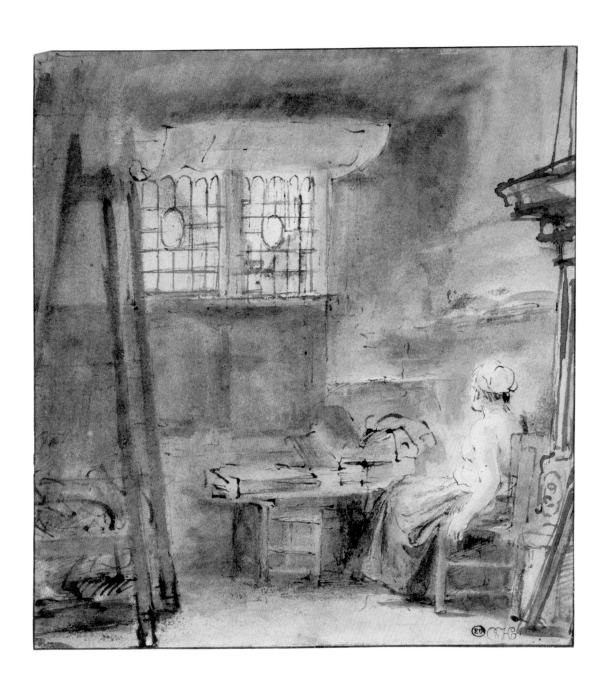

27 · Farm Buildings beside a Road

Pen and brown ink with grey wash (added later) on oatmeal-coloured paper. · 12.8 × 23.6 cm
Presented by Chambers Hall, 1855 · WA1855.14

The Breestraat where Rembrandt lived in Amsterdam ended at the sea wall, known as the Diemerdijk. This was a favourite spot for Rembrandt and his contemporaries. It appears frequently in drawings and etchings by himself and by his fellow artists. The same farm buildings appear again in an etching (B.213) seen from a similar viewpoint. Although the etching appears to show the buildings from the wall, the drawing was made from lower down the road that runs along the wall.

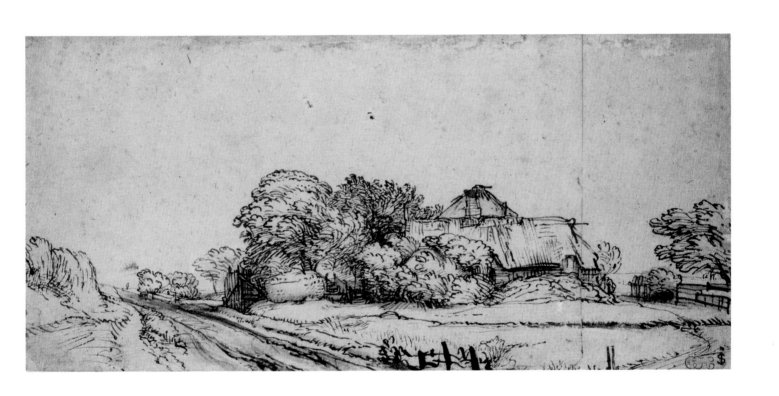

28 · Landscape with Ascanius Shooting the Stag of Sylvia

Black chalk with pen and brown ink and white bodycolour,
inscribed with diagonal and horizontal lines in graphite · 25 × 31.5 cm
Inscribed in pen and brown ink at lower left: *libro.7 di/ Virgilio/ Claudio 1682*; and in lower
centre: *Come Ascanio caetta* [*il cervo* paintedout and reinscribed] *di Silvia/ figliola di. Tirro*;
behind the figure of Ascanius: *Roma 1680 / CLAUDIO / I.V.F.*
Presented by Mrs W. F. R. Weldon, 1926 · WA1926.8

In his lifetime, Claude Lorrain enjoyed an immense reputation as a landscape
painter who could compose scenes from the Bible, history and literature by com-
bining the traditional artifice of landscape painting with a new feeling for natural
effects. The many light-filled studies drawn by him during sketching expeditions
into the countryside near Rome along with preparatory compositions, drawn from
his imagination, gave him the materials for the paintings which he made in the
studio. Most of Claude's many surviving drawings belong to one or other of these
two groups: nature studies on the one hand and relatively finished compositions
on the other. This is a study of the second kind, made for Claude's last painting,
signed and dated 1682.

The two dates on the drawing suggest that he worked on the composition over a
period of years. The painting was commissioned by Prince Onofrio Colonna, whose
family claimed descent from the legendary Trojans, Aeneas, and his son, Ascanius.
It was Colonna who must have suggested that he should choose a subject from
Virgil's epic poem, *The Aeneid*, which told how his supposed ancestors wandered for
many years after the fall of Troy and how they eventually arrived in Italy. In this
episode, Ascanius shoots a stag that belonged to the children of an official from a
local tribe. The incident provoked a war lasting many years between the Trojans and
the resident people. Claude carefully inscribed the drawing with a brief description
of the subject and a reference to its source and added a similar inscription on the
finished painting.

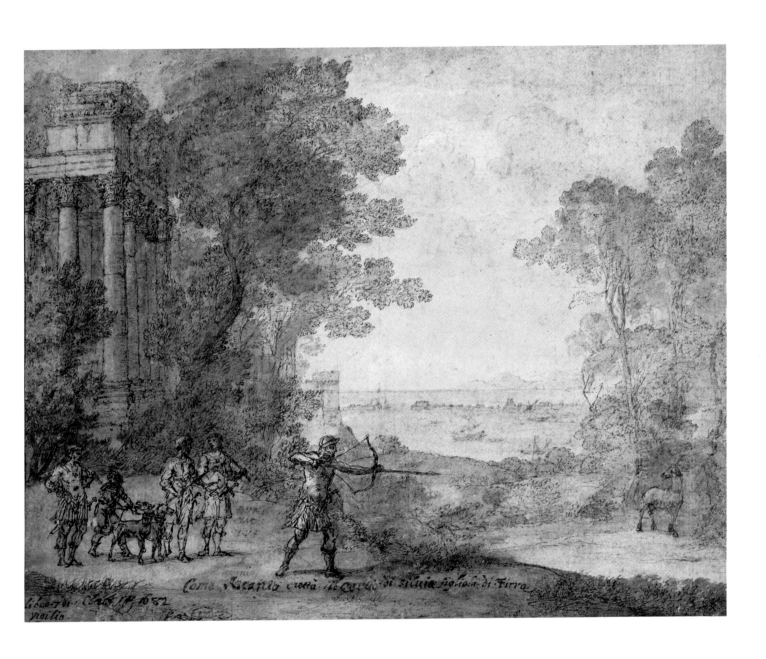

Come Ascanio cacca il cervo di siluia figliola di Tirra

Claudio Clef IV 1682
invilio

29 · *Portrait of Thomas Howard, 2nd Earl of Arundel*

Pen and brush with brown ink over black and red chalks · 27.5 × 19.3 cm
Purchased with grants from the National Heritage Memorial Fund,
the Art Fund, The MGC/V&A Purchase Grant Fund, The Michael Marks Charitable Trust
and the Friends of the Ashmolean, 1994 · WA1994.27

Rubens, like Titian before him, was an artist whose career spanned the continent of Europe. His reputation as one of the greatest artists of the early seventeenth century and his work as a diplomat brought him into contact with important patrons in several countries. From June 1629 until March 1630, he was in London on a mission on behalf of Archduchess Isabella of the Netherlands to promote peace between England and Spain. During this visit, Rubens met Thomas Howard, 2nd Earl of Arundel, for the first time. Arundel was a notable collector of art and antiquities and a prominent diplomat at the courts of James I and Charles I. Rubens described him as "one of the four Evangelists and the Supporter of our Arts". This portrait must have been drawn by Rubens in Arundel House in 1629 or 1630. Rubens made a second portrait drawing of Arundel, now in Williamstown, which he used as a model for a life-sized portrait, now in the Isabella Stewart Gardner Museum in Boston. The drawing in Oxford is a more elaborate work, drawn first in black chalk and the flesh tinted with red chalk. Hair and fur are reinforced with pen and ink, and brown wash is used to complete the costume. He wears, round his neck, the ribbon of the Lesser George, one of the orders of the Garter. Arundel wears the same fur coat and ribbon in a portrait by Rubens, now in the National Gallery in London, which must have been painted at the same time. Perhaps the Oxford portrait was done as a study for the painting, but the highly wrought character of the drawing suggests that it was made as a work of art in its own right.

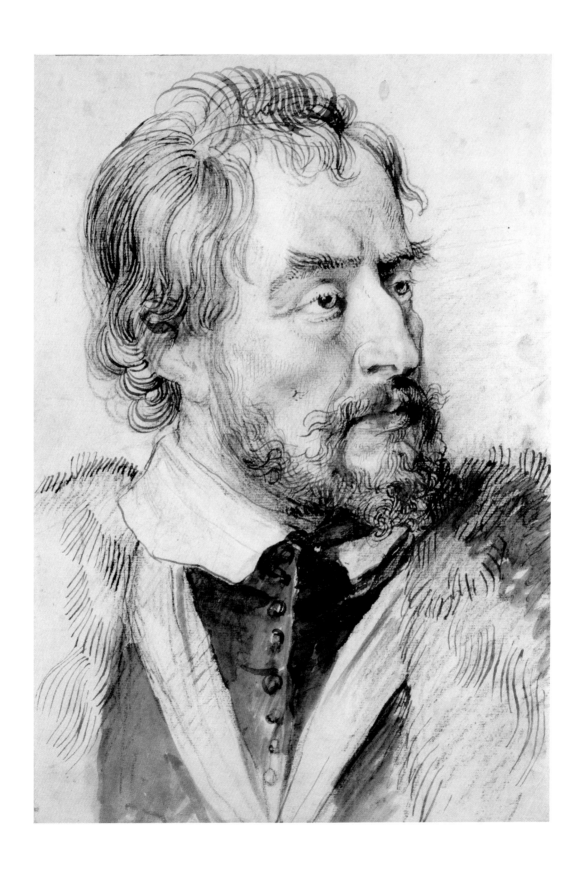

30 · A Nude Man Seen Partly from Behind

Black chalk heightened with white chalk · 31.5 × 36.7 cm
Presented by Chambers Hall, 1855 · WA1855.154

When Rubens returned to Antwerp in 1608 after eight years in Italy, his talent was immediately acknowledged. In 1609 he was appointed court painter to Albert and Isabella, Archduke and Archduchess of Austria, and he received the first of a long series of commissions for altarpieces and other works. His first major undertaking after his return to the north, *The Raising of the Cross*, a large triptych painted in 1610–11 for the church of St Walpurgis in Antwerp, established his reputation as the leading artist in the Low Countries and heir to the artists of Italy. The painting, and this study for one of the figures straining under the weight of the cross, show how much Rubens had learnt in his Italian years from Michelangelo and from muscular antique sculptures like the Laocöon and the Belvedere Torso. Rubens followed the Italian practice of making preliminary compositional sketches and then working out the figures in detail by drawing them from life. This study was made as a guide to the upper half of the figure, ending at the waist, below which the body in the painting is concealed by drapery. In the altarpiece, the figure is even more muscular, and his backward slope has been slightly reduced to give greater emphasis to the upward thrust of his body. Drawings like this provided models not only for Rubens, but also for his studio assistants who helped Rubens to complete his many commissions.

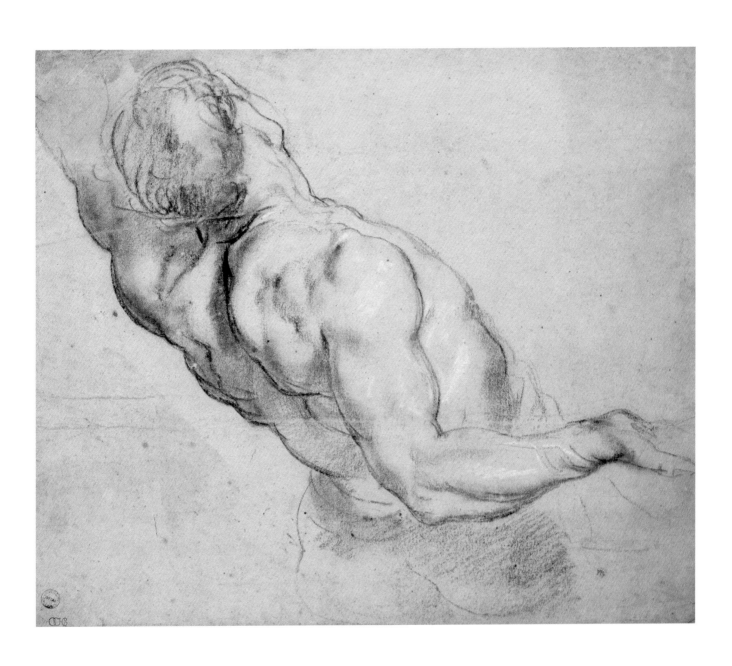

31 · Woodland Scene

Black chalk, touched with red chalk and white bodycolour on stone-coloured paper
38.3 × 49.9 cm · Presented by Chambers Hall, 1855 · WA1855.122

After Rubens had bought a house and estate at Het Steen, near Mechelen, in 1635, he spent much time painting landscapes and drawing in the open air. The pleasures of the countryside and the solitude it offered must have brought him contentment at the end of a lifetime of travelling and working for his many patrons. Drawings like this were probably made as an end in themselves although they could also have given him details for the landscapes he painted in the studio. The place where Rubens was seated, close to a stone bridge by the side of a path leading into an area of woodland, is not remarkable for its beauty, but it has a quiet charm, and the pleasure of the moment is delightfully conveyed. The light, reflected in the stream running under the bridge, is brightest at the horizon, indicating an evening or a morning scene. The little comma-like touches of red chalk on the ground and in the tree on the left may represent flowers and blossom, leaves or spots of golden light catching the foliage. According to Rubens's biographer, Roger de Piles, he often drew in the open air at sunrise and sunset. This may be true since the author had consulted Rubens's nephew for the details of his biography, but it is difficult to prove as few landscape drawings by Rubens have survived. He undoubtedly made many others which have been lost.

32 · Head of a Youth

Black and white chalk on brownish paper · 31.5 × 29.9 cm
Purchased, 1934 · WA1934.266

This beautiful study of a youth (sometimes called a young ensign), belongs to a large group of drawings which Piazzetta made as independent works of art for a collector. These elaborate drawings are of expressive heads, many of young men and women, occasionally in groups of two or even three. By the 1740s, they were attracting the attention of a wider public, and many were reproduced in engravings and mezzotints.

Piazzetta chose a warm-toned brown paper for this drawing, and the blank areas convey the lighter parts of the flesh, while some white chalk is used very sparingly where the light, falling from the left, hits the boy's face. The black chalk was first rubbed gently (and probably moistened) to create a soft grey film of shadow, which was then worked over, building up a marvellous tonal range, and creating a variety of textures. The position of the tassel on the shoulder was altered in the process. The same models recur in Piazzetta's drawings, and he may well have posed members of his family, such as his son Giacomo, although many of the heads are idealised.

Piazzetta was a slow and careful worker by nature. In his paintings, the figures have a solidity of form and intensity of expression which result equally from his masterly, deliberate handling of paint, and from his close attention to the psychology of his protagonists. The same artistic and human interests are seen in these finished drawings, which are absolutely suited to his temperament. In Venice he ran an important 'Scuola del nudo', a life-drawing class frequented by the young Tiepolo. As a result of his reputation as an excellent teacher and draughtsman, he became the first Director of the new Venetian state academy in 1750.

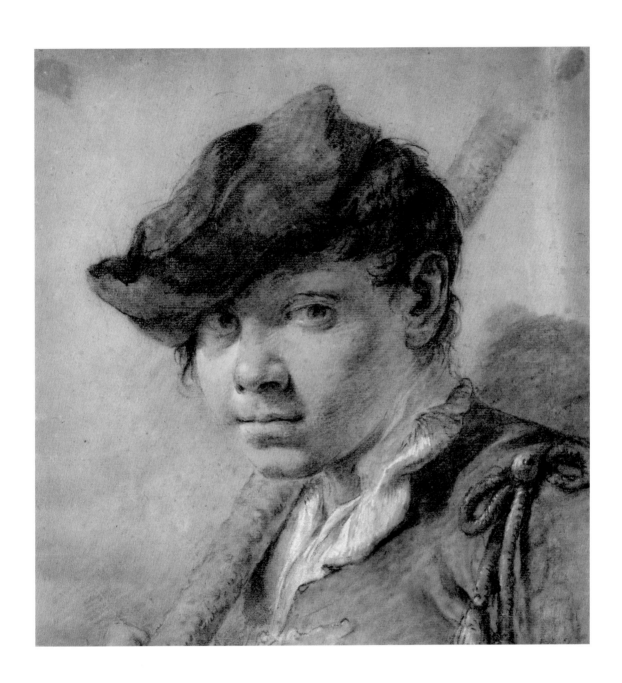

33 · Head of an Old Bearded Man

Red and white chalk on blue paper · 26 × 18 cm
Purchased, 1934 · WA1934.267

Tiepolo made this confident, vigorous study in preparation for one of the spectator figures in the *Miracle of St Anthony of Padua*, an altarpiece in the parish church at Mirano in the Veneto, painted towards the late 1750s. By now a well-to-do artist of international renown, Tiepolo had acquired a villa at Mirano as a place where his family could escape the heat of a Venetian summer, and the altarpiece was a local commission.

Red and white chalk on blue paper was favoured by Giambattista for preparatory studies of heads, hands and details of costume. The white chalk is applied in delicate touches, conveying both the fall of light on the features, and the texture of the old man's beard. While one eye is in shadow, the other is brilliantly drawn, with a couple of touches of white used to dynamic effect. The boldness of the red strokes against the grain of the paper, together with the light dabs of white, adds a sense of vibrancy and luminosity to the drawing. This is entirely appropriate for the drawing's expressive purpose, as a study of the awe and reverence of a humble figure witnessing a miraculous event.

Enough of Giambattista's preparatory work for the altarpiece survives – an oil sketch, pen and ink compositional studies, and chalk drawings of details – to illustrate how carefully he planned the painting. However, this commission came at a very busy time. In the late 1750s he worked on extensive fresco decoration at the Villa Valmarana near Vicenza, on a series of painted ceiling canvases for an important Russian patron, and on an enormous altarpiece for the Duomo at Este, amongst other commissions. Giambattista relied on his son Domenico, who was his chief assistant and collaborator, for the execution of the Mirano altarpiece to the master's detailed designs.

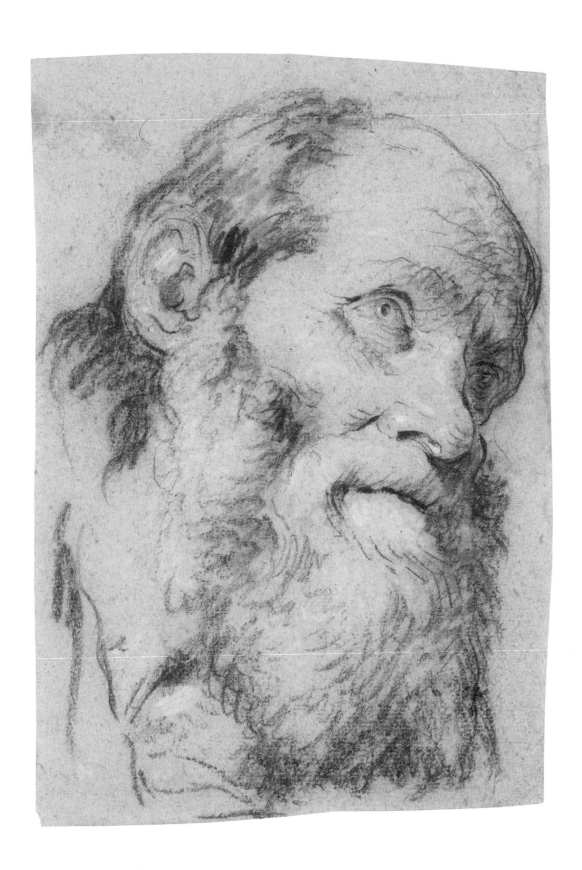

34 · Two Men Fighting

Brush drawing in brown and grey washes on cream paper · 20.6 × 14.1 cm
Bequeathed by Francis Falconer Madan, 1962 · WA1962.17.54

Goya used the brush and different shades of wash for this study of a murderous group of two men, naked but for some animal skins. He visualised the horrific moment when the fallen, writhing man anticipates the blows of the weapon grasped by his tense antagonist. The violence of the subject is echoed in the fierce handling of the medium.

The drawing has been called *Samson and the Philistine*, or *Cain and Abel*, but Goya did not necessarily have a particular subject in mind, other than the ubiquity of aggression. Around the same time, Goya made a profound exploration of human brutality in his *Disasters of War* etchings, begun about 1810, while some of his small pictures painted in the war years of 1808–14 also illustrate savage themes of murder, torture and rape. This was a time of upheaval, fear and violence in Spain, between the Napoleonic invasion of 1808 and the reinstatement of Ferdinand VII in 1814.

The drawing comes from an album of brush and ink sketches, one of eight albums which Goya planned and compiled as coherent sequences, purely for private purposes. They were later re-arranged by his son Javier, and were broken up for sale in the 1850s. This drawing was contained in an album entitled 'Images of Spain', which included drawings spanning the years 1812–20, the majority of which were made in 1815–20. The subjects include scenes of imprisonment, torture and death. There are violent and grotesque subjects, scenes of duelling and hunting, and also some everyday scenes of crowds at the Casa del Campo (near where Goya bought his house, the Quinta del Sordo, in 1819). Goya numbered the drawings up to 106. The number 57 is brushed in ink at the top of this sheet, which is slightly cut. He gave captions to some of them, in a tone of irony or despair. The drawing preceding this one depicts a scene of torture.

14.

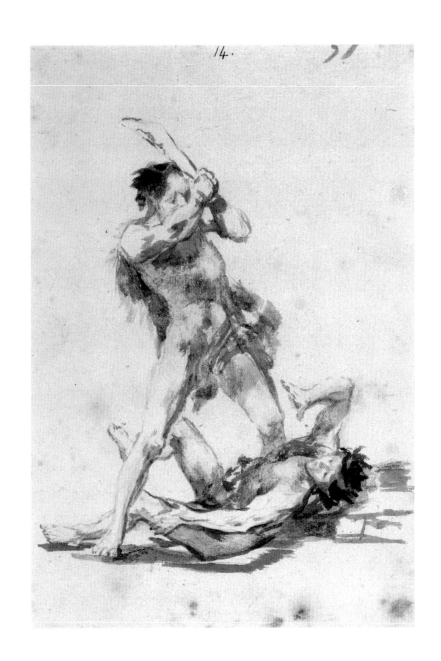

ANTOINE WATTEAU 1684–1721

35 · *Head of a Boy Facing Right*

Black and red chalks on stained off-white paper · 14.9 × 13.3 cm
Purchased, 1937 · WA1937.126

Watteau frequently made drawings of things seen in passing or of friends pos-
ing for him informally. These gave him a stock of images which he used when
composing paintings. This was an unusual way of working, as most artists start
with an idea of the composition and then make corresponding drawings of the
figures. Watteau's habit meant that figures, based on his drawings, can appear in
several compositions while others remained unused. There are a number of heads
in Watteau's paintings which are similar to this but none that can be said with any
confidence to have been based on it. The smoky effect of smudged chalk, combined
with delicately blended blacks and whites, is a characteristic of his work after 1717.
The technique is distantly descended from the work of Rubens, an artist whom
Watteau greatly admired and occasionally copied.

36 · *Girl Seated with a Book of Music on her Lap*

Black, red and white chalks on coarse-textured brown paper · 24.5 × 15.6 cm
Presented by Emma Joseph, 1942 · WA1942.46

Watteau's practice of using figures from a stock of studies meant that they often appear more than once in his work. This study of a seated girl appears in *The Concert* (Potsdam, Schloss Sanssouci) and again in an engraving by Louis Surugue *Pour nous prouver que cette belle*, dated 1719, probably based on a painting in the Wallace Collection in London. The figure in the Potsdam painting is closer to the Ashmolean drawing than the figure in the print and in the London painting, and must have been the earlier of the two. The Potsdam painting has been dated between 1715 and 1717. The drawing cannot be much earlier than this. The technique of three chalks used in the drawing seems to have been adopted by Watteau in *c.*1715, inspired by the work of contemporaries like Charles La Fosse, who used it habitually and, more remotely, by Rubens, an artist whom Watteau admired and imitated.

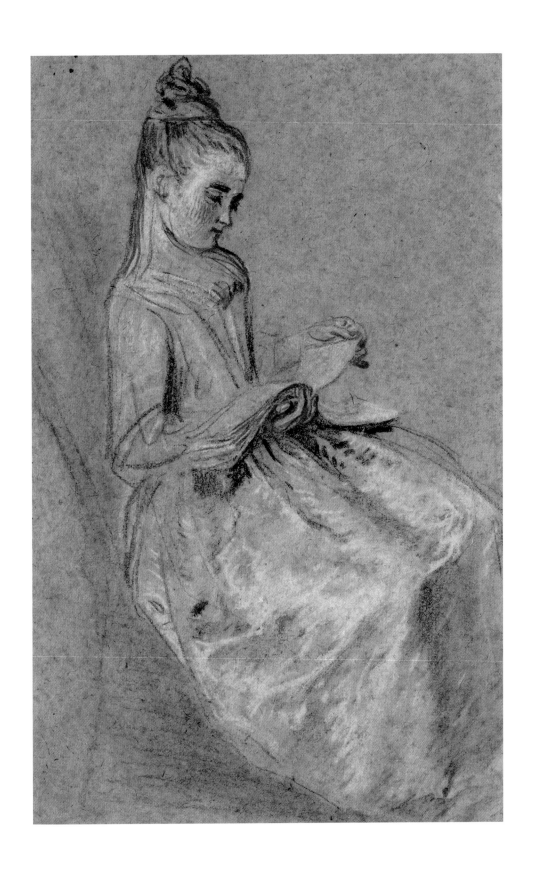

FRANÇOIS BOUCHER 1703–1770

37 · The Invention of Drawing

Brown chalk on off-white paper · 15.9 × 21.2 cm
Presented by Langton Douglas, 1938 · WA1938.42

During a long and influential career as the leading French artist of his generation, François Boucher made prints and book illustrations, painted altarpieces, genre scenes, landscapes, historical, mythological, allegorical and literary compositions and contributed designs for tapestries and porcelain. The purpose of this drawing is unknown but it has been suggested that Boucher's use of brown chalk was linked to the studies he made in the 1760s for prints in the 'crayon manner', a technique for making facsimiles of chalk drawings. The subject shows a daughter of Butades, a potter in ancient Greece, tracing the shadow of her lover on a wall. The tale appears first in Pliny's encyclopaedic *Natural History*, written in the first century AD. In the eighteenth century, the story became associated with the discovery of painting, inspired, initially, by an illustration in Joachim von Sandrart's *Teutsche Academie* of 1675 and by Simon Gribelin's frontispiece in John Dryden's translation of Dufresnoy's *The Art of Painting* of 1716. Gribelin's illustration no doubt explains why the subject was taken up, in particular, by British artists, who painted several different versions of the theme in the 1770s and 80s. It became very popular subsequently in France and elsewhere during the period when neoclassicism was in fashion. Boucher's composition, probably drawn in the 1760s, is one of the earliest treatments of the theme by a major artist. The young girl is known in some accounts as Dibutades. She leans across to trace the shadow of her lover and as she is drawing with her left hand, it is almost certain that Boucher had a print in mind.

38 · *Landscape with a Bridge*

Red chalk on off-white paper · 23.4 × 37.2 cm
Accepted by H.M. Government in lieu of Inheritance Tax and allocated to
the Ashmolean Museum, 2010 · WA2010.62

This drawing was probably made in the summer of 1760 when Fragonard stayed at the Villa d'Este at Tivoli, near Rome, as a guest of the Abbé de Saint-Non. Here he executed a number of evocative red-chalk drawings of the famous park and gardens, laid out on the slopes of Tivoli by cardinal Ippolito d'Este in the sixteenth century. Fragonard had gone to Rome in 1756 as a result of winning the Rome Prize. This was then seen as a stage in the formation of academic history painters, but Fragonard spent much of his time in Italy out of the studio drawing the landscape and the antiquities. With Hubert Robert, whom he met in Rome, he toured the famous sites and picturesque views, recording them in red chalk, often in highly finished drawings for sale to collectors. Fragonard and Robert drew in a similar manner although Robert had a lighter, more descriptive touch than Fragonard. In drawings like this, Fragonard not only records what he has seen but endows the abandoned garden with an air of mystery and melancholy.

SIR THOMAS LAWRENCE 1769–1830

39 · Portrait of Susan Bloxam

Black chalk, touched with red chalk, and
lightly stumped on white, discoloured card · 26 × 21.7 cm
Bequeathed by Kenneth Garlick, 2009 · WA2009.159

Thomas Lawrence was known in the early years of the nineteenth century as one of the greatest portrait painters of the age. He was also a fine draughtsman, drawing his sitters with a quiet virtuosity that contrasts with the flamboyant manner of his painting. This portrait of his niece, Susan Bloxam, drawn in pale grey chalk and delicately coloured with pink, was drawn on 1 March 1818 on a visit to the artist's brother, the Reverend Lawrence, vicar of St Luke's chapel at the Haslar naval hospital in Hampshire. Susan, daughter of Lawrence's sister, Anne, was also visiting her uncle, possibly for treatment at the hospital as she died at Haslar nine months later. Lawrence was distraught by the news but took some comfort from the thought that he had made the present drawing: "I have lost a sweet, good, modest, little being in my niece, Susan. I feel thankful that this one talent which God has given me has, in this case, afforded consolation to my sister and her family, by perpetuating the form and expressing the nature of this lovely, lamented being, my dear Susan". Shortly after, Lawrence commissioned a print of the portrait from the engraver F. C. Lewis.

40 · *Portrait of Jean-François-Antoine Forest*

Graphite on slightly discoloured white wove paper · 31.5 × 22.4 cm
Signed and dated lower right: *Ingres Firense 1823*
Purchased with a grant from the Art Fund, 1936 · WA1936.223

As a result of winning the prestigious Rome Prize, Ingres went to Rome in 1806 and there earned a reputation among his friends and colleagues as an outstanding portrait draughtsman. Ingres did not value his portraits as highly as his history paintings and resented the necessity that forced him to earn a living by drawing tourists, particularly after the fall of the Napoleonic dynasty in 1815 and the loss of his former patrons. In 1820, he moved to Florence in the hope of finding better work. During the months he spent in Florence, Ingres drew a number of portraits, including this one of Antoine Forest, an obscure architect from Lyons. Forest carries a pencil and portfolio and wears an outdoor coat, no doubt for sketching in the open air. He turns with a genial smile towards the artist. The vivacity of the drawing, which is more typical of the portraits drawn by Ingres of his close colleagues than it is of his commissioned work, seems to confirm an inscription on the back that describes the sitter as a friend of the artist. The costume is rapidly outlined with a sweep of the pencil, while the head is more carefully detailed with darker notes made with a softer point.

41 · A Rustic Scene in Antiquity

Black chalk on white paper · 26.8 × 38.2 cm
Purchased, 1985 · WA1985.229

In the aftermath of the French Revolution, several established artists, including Girodet, found work illustrating a series of editions of the classics published by Pierre Didot. These books inspired Girodet to undertake a series of drawings on his own account, illustrating a number of ancient texts which he intended to reproduce in prints. By the time of his death, Girodet had completed 171 illustrations for Virgil's *Aeneid* and four for his *Georgics*. These were not drawn with the elaborate shading that he used in the drawings he made for Didot but were executed in simple outline, imitating John Flaxman's popular illustrations for Dante's *Divine Comedy*. This drawing is one of the four known for Virgil's *Georgics*. It illustrates a passage in the text which describes a scene in winter when the farmer sharpens stakes beside the fire while his wife works at the loom or boils the juices of the grape. The different light sources that feature in the composition – the moon, seen through the open door, the fire in the hearth and the oil lamp suspended from the ceiling – all suggest strong contrasts of light and shadow, but these are conspicuous only by their absence.

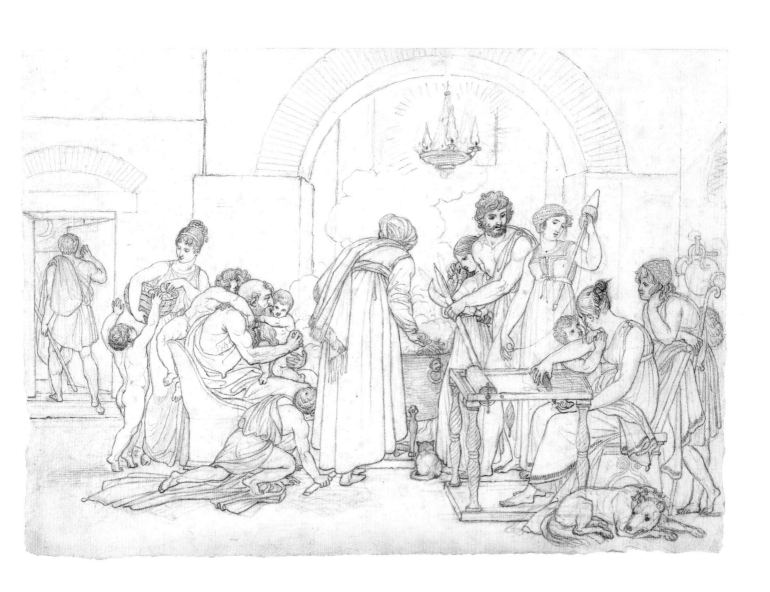

42 · Portrait of the Artist's Wife, Nina

Pencil on white paper · 20.5 × 18.3 cm
Watermark: J. WHATMAN / TURKEY MILL. 1825
Bequeathed by Dr Grete Ring, 1954 · WA1954.70.128

Overbeck was born in Lübeck into a family of Protestant pastors. In 1806, he enrolled in the Vienna Academy but became disillusioned with the curriculum, chiefly because it lacked the spirituality which became central to his art. In 1809, he settled in Rome with a number of fellow students and was a founder member of the group of artists known as the Brotherhood of St Luke, or the Nazarenes as they were called on account of their pious ways. They took their inspiration largely from the art of Raphael and his predecessors, painting in clear bright colours and drawing in simple, precise contours, imitated from the art of the Italian fifteenth century. This portrait of Overbeck's wife, Nina Hartl, recalls the type of image of the Virgin Mary that he admired in the work of Perugino and the young Raphael. It may have been made for a family portrait which he completed in 1830, now in the Behnhaus in Lübeck. Nina Hartl was born in Vienna in 1790. In 1814 she went to Pisa for the sake of her health and met Overbeck in Rome in the spring of 1818. Overbeck had by this date converted to Catholicism, and they were married in October 1818 in the church of Sant'Andrea delle Frate according to the Roman Catholic rite.

43 · The Ponte Salario near Rome

Pencil on off-white paper · 22.4 × 34.1 cm
Signed and dated in pencil lower right: *Ponte Salario bei Rom. J.C.Erhard 1821*; and in pencil
lower left: *Ponte Salario*
Bequeathed by Dr Grete Ring, 1954 · WA1954.70.82

Erhard was born in Nuremberg where he received his first training in art at the local drawing school. He was in Vienna from 1811–14 and again from 1816–19 when he made a number of sketching excursions into the Danube region, Upper Austria and the Salzkammergut. The drawings which he made on these tours became the basis of a number of vivid etchings. In 1819 he left for Rome, where he stayed until his death in 1822. His time in Italy produced many studies from landscape made in the company of fellow artists from the German colony. This carefully descriptive drawing dates from Erhard's first summer in Italy. The ancient Roman bridge taking the Via Salario over the river Aniene, was a favourite motif among the many artists who worked in the Italian countryside. Erhard drew it several times and recorded it, at least once, in a watercolour (Kunstmuseum, Düsseldorf), seen from further back along the road leading to the bridge. Erhard shows the bridge as it was before its wide central arch was damaged by the French army in 1849 and finally demolished by papal troops in 1867.

Ruth Silvers.

Ponte Salario bei Rom, J. C. Erhard 1821.

44 · *Landscape in Bohemia*

Pen and brush with brown ink · 11.4 × 18 cm
Inscribed: *den 6t May 1803* · Bequeathed by Grete Ring, 1950 · WA1954.70.92

45 · *Landscape with an Obelisk*

Pen and brush with brown ink · 12.9 × 20.2 cm
Inscribed: *den 25t May 1803* · Bequeathed by Grete Ring, 1950 · WA1954.70.93

Friedrich's landscapes are infused with an intense spirituality. His preoccupation with the theme of death and resurrection was expressed through a new, deeply felt symbolic use of trees, sea, mountains, snow and mist. These landscapes were painted in the studio, partly from memory, partly from drawings made in the open air. Friedrich began drawing from nature in about 1797 when he was a student at the Copenhagen Academy and continued for the rest of his life to fill sketchbooks with studies of single trees, rocks and other motifs along with more elaborate views. The two drawings shown here were both made in a sketchbook taken by Friedrich on an excursion to Bohemia and Saxony in 1803. The first shows a view of Mount Jeschen, seen across a ploughed field near Reichenberg. The second, drawn about three weeks later, may have been drawn in Saxony with what could be a view of the town of Stolpen in the distance. The little obelisk has been identified as a milestone of a type used by the Saxon postal service. This drawing includes also a small cross, placed inconspicuously at the centre of the landscape, which may have no precise significance, although it brings to the scene a touch of the religious emotion that is never far from the surface in Friedrich's work. The thin, frail pen lines, washed in with different strengths of sepia, are typical of his finished drawings.

46 · *Study of a Woman Seen from Behind*

Black chalk and stump, heightened with white on grey-green paper · 49 × 30.5 cm
Bequeathed by Mrs Alice Mott in memory of her husband,
Charles Egerton Mott, 1959 · WA1959.9

After he moved to Bath in 1759, Gainsborough painted full-length portraits as a matter of course. To prepare himself, he made a number of large-scale chalk drawings, probably studied from clothed articulated dolls. The present drawing is similar in style and technique to this group but, unlike them, it must surely have been drawn from life. With the motif of the dress lifted to expose the ankle, it is one of the most purely feminine and enchanting drawings made by the artist. Gainsborough brilliantly catches the spontaneous movement of the figure seen unusually from the back as she moves away from the artist. The style of the mushroom hat and high heels suggests that it was drawn between 1760 and 1770.

The drawing belongs to a group of studies which the artist kept in his possession and bequeathed to his wife. Although she attempted to sell as many as she could, the present sheet passed to their younger daughter, Margaret. There is no evidence for the attractive notion, dating from the nineteenth century, that the drawing shows Gainsborough's wife on her way to church.

47 · *The Earl of Morton Carrying the Sword of State*

Black and red chalk with watercolour and bodycolour · 50.3 × 37 cm
Purchased, 1935 · WA1935.124

David Wilkie was one of the greatest nineteenth-century British draughtsmen. When still a student at the Trustees Academy in Edinburgh, he found success with a painting of Pitlessie Fair, an ambitious composition marked by the influence of the Dutch Old Masters that characterised much of his art after he had moved to London in 1805. Brushwork and drawing were inextricably combined in everything he did, not only in his finely painted early works but also in the bolder manner that he adopted after returning from a tour of the Continent in 1828. This portrait of George Douglas, 16th Earl of Morton, was drawn in preparation for a painting of King George IV's entry into Holyroodhouse on 15 August 1822. Wilkie had arranged with the chamberlain's office to watch the king's arrival from an attic window in the palace. In 1824, he was given three sittings by the king and in September, he returned to Scotland to prepare several of the other portraits, including the likeness of the Earl of Morton holding the Scottish Sword of State which he had carried at the ceremony. Morton is drawn with vigour and character, grasping the great sword in a firm hand and looking with eagle eyes in the direction of his monarch, who appears in the painting striding forward from the right. In the final work, the earl is shown on horseback although there is no reason to suppose that Wilkie did not have this in mind already when he made the drawing.

48 · *Entrance to the Valley of the Grande Chartreuse in Dauphiné*

Watercolour on paper · 26.2 × 37.7 cm
Bequeathed by F. Pierrepont Barnard, 1934 · WA1934.92

John Robert Cozens, son of the landscape painter Alexander Cozens, worked in a tradition of topographical watercolours which, in the course of his short life, he transformed into an art form that could stand alongside contemporary poetry and romantic fiction as a vehicle for expressing mood. He first went to Italy in 1776, travelling part of the time with the connoisseur and antiquarian Payne Knight, and returned there in 1782, in the company of the wealthy writer and collector William Beckford, for whom he painted the present watercolour and many others. This image of the valley of the Grande Chartreuse, north of Grenoble, was based on a drawing in a sketchbook made as the two travellers crossed the mountains of the Dauphiné. With limited colour and little detail, Cozens evokes the still, solemn grandeur of the scenery, contrasting the dark mass of the nearby cliff with the delicate pink of the evening sky. The drawing remained in Beckford's possession until he sold it at Christie's in 1805.

49 · *The Transept of Tintern Abbey, Monmouthshire*

Pen and black ink with watercolour over pencil · 35.5 × 26 cm
Inscribed in ink, lower right 'Turner'
Purchased, 1917 · WA1917.3

The ruined twelfth-century Cistercian abbey at Tintern on the river Wye was one of the most celebrated sites in Britain for late eighteenth-century tourists in search of the Picturesque. Turner visited it first in 1792 and again in 1793. Drawings made by him during these visits gave him material for at least two substantial watercolours, one exhibited at the Royal Academy in 1794 and a second, either the present watercolour or a variant in the British Museum, exhibited in 1795. His early training as a topographical draughtsman is evident in the precision with which he has drawn the columns and arches and carefully indicated the smallest architectural detail. The view, looking towards the north transept, is generally accurate although the scale has been exaggerated to give the scene an air of Romantic drama. The colour, added over careful outlines in pencil, is subdued and limited to browns and muted blues. Turner, at this stage in his career, was not yet interested in colour but conveys the drama of the ruined arches through contrasts of tone. The sun, shining through the windows on the east side and lighting up the crossing, suggests a morning view, although Turner could easily have invented this detail for the sake of creating a picturesque effect.

50 · *Venice: the Accademia*

Watercolour over pencil with pen and red and black inks and some scraping out
21.7 × 31.8 cm · Presented by John Ruskin, 1861 · WA1861.9

This view looking across to the south bank of the Grand Canal was drawn in 1840, probably in a sketchbook, on Turner's last visit to Venice. The Gallery of the Accademia, recessed between flanking buildings, appears near the centre with the former Chiesa della Carità on the left. The Gallery had been built in the grounds of the convent of Santa Maria della Carità in 1807 when the convent buildings were converted to house the Venetian Academy. Even making allowances for the changes that have been introduced in the architecture of the buildings and the addition of a bridge across the canal in 1854, it cannot be said that Turner's view is topographically accurate. The domed lanterns on the church (now removed) are truncated, and the building itself has been compressed. Details are difficult to identify. The statue of a lion bearing Minerva on its back, perched over the entrance to the gallery (since removed and now in the Public Gardens), is no more than a faint scribble. The edge of the canal is barely indicated while the architecture of the gallery façade is so altered that one wonders how much of the view Turner drew on the spot and how much he added later. The watercolour, however, is not a work of topography but an evocation of the light and atmosphere of Venice, blurred like a memory. The essentials are vivid but the detail has faded with the passage of time.

51 · Evening: Cloud on Mount Rigi, Seen from Zug

Watercolour over faint indications of pencil · 21.8 × 26.7 cm
Presented by John Ruskin to the Ruskin School, 1871 · WA.RS.ED.300

During the Peace of Amiens in 1802, when hostilities between France and England were briefly suspended, Turner made a tour through France and Switzerland. He was profoundly impressed by the grandeur of the Alps but did not return there until the mid-1830s. From 1841 to 1844 he went there annually, making many sketches and watercolours of the scenery. This view of Mount Rigi, drawn in the early 1840s, was one of his favourite subjects. It shows the mountain on the far side of Lake Lucerne, seen from a window of the inn where he was staying at the time. The forms are very lightly defined with some meandering pencil lines, and the impression of the scene depends almost entirely on colour: pale mauve crossed with white clouds on the mountain, blue in the reflection in the water and yellow for the land in the middle distance. Unlike his first topographical work, which combines limited colour with sharply defined detail, his later work becomes increasingly evanescent and atmospheric.

52 · *Beatrice and Dante in Gemini, amid the Spheres of Flame*

Watercolour with some pen and ink over pencil and black chalk · 35.5 × 51 cm
Inscribed in pencil in lower right *'Paradiso Canto 24'*
Acquired by a syndicate organised by the Art Fund and allocated to the Ashmolean, 1918
WA1918.5

Late in life, Blake was commissioned by the painter John Linnell to produce 102 watercolour illustrations to Dante's *Divine Comedy* as the basis for a set of prints. Blake began work in 1824 but the series was still unfinished when he died in 1827. As the inscription indicates, this watercolour illustrates a passage from *Paradiso*, the third and final book in the *Divine Comedy*. Dante, conducted by Beatrice through the spheres between earth and heaven, stops in the sign of Gemini, under which Dante had been born, to look back towards Earth and the seven planetary spheres through which they have passed in their ascent to Paradise. Blake ingeniously suggests the idea of Gemini, the celestial twins, by placing Dante and Beatrice together within two encircling spheres overlapping at the centre to enclose both figures. The spirits of the Blessed appear faintly in the spheres. At the time of Blake's death, the watercolours were left in various states of completion, some simple sketches, others highly finished. A syndicate of seven museums, including the Ashmolean, purchased these from Linnell's heirs in 1917 and distributed them to the members. The Ashmolean acquired three fine sheets of which this is the most beautiful.

53 · Self-Portrait

Black and white chalks on buff paper · 29.1 × 22.9 cm
Purchased, 1932 · WA1932.211

Palmer's progress between 1818, when he decided to become an artist, and the following year, when he had a work accepted at the Royal Academy, was rapid. To judge by this self-portrait, generally thought to have been made in 1824–5, he had achieved perfect mastery in the art of drawing by the age of twenty. He may have been thinking of following a career in portraiture as there are references to other portrait drawings by him from this period but none, apart from this drawing, can now be identified. There is little to compare it with in Palmer's other work. He had, by this date, already met John Linnell who encouraged him to follow his visionary path, and it perhaps marks the end of a more conventional phase in his career. It is a frank, unflattering image observed with particular intensity. It has often been described as an archetypal image of the Romantic artist, although the penetrating character of Palmer's gaze and his solemn expression may have more to do with the lengthy concentration required by the artist while scrutinising his features in the mirror.

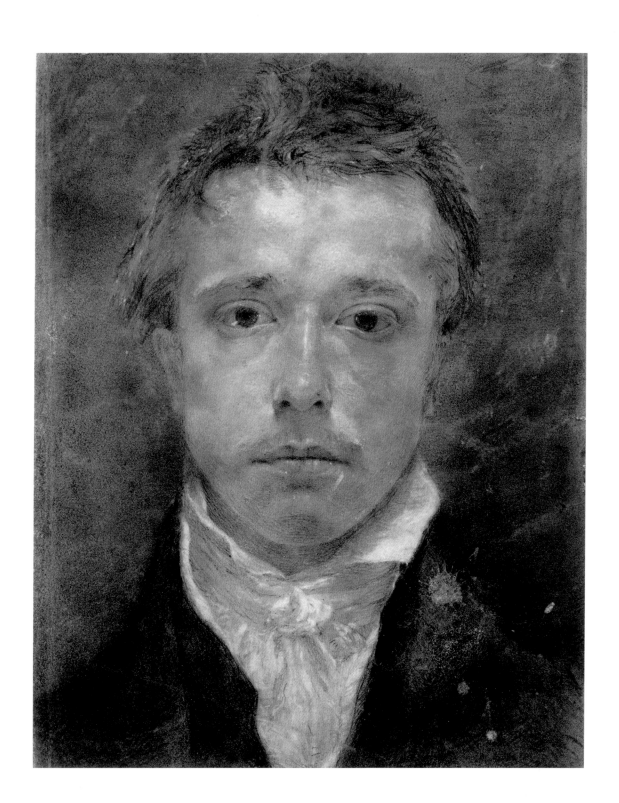

54 · A House and Garden at Tintern

Pen and brush with brown ink, watercolour, gouache, graphite and black chalk on
off-white paper, toned with discoloured grey wash · 37.2 × 47.5 cm
Purchased, 1939 · WA1939.75

The strange, dream-like images that Palmer made while living at Shoreham in Kent
from the mid-1820s until the mid-1830s, were not appreciated by his contempo-
raries. From 1835 onwards he began to work in a more conventional topographical
manner, visiting popular, picturesque sites in North Devon and Wales in search
of more saleable themes. Palmer was disappointed by the famous scenery of the
Wye Valley which he visited in the summer of 1835 but was impressed by the ruins
of Tintern Abbey and by the countryside in the neighbourhood. This farm build-
ing near Tintern with a prominent fig tree and hollyhocks in the garden may be
the one which he mentioned in a letter of 19 August to his fellow artist George
Richmond: "I saw a man this evening literally 'sitting under his own fig tree' whose
broad leaves mixed with holyoaks and other rustic garden flowers embower'd his
porch". Typically, the sense of peace and harmony that Palmer associated with the
countryside brought to mind a text from the Book of Micah which refers to a time
when the nations "shall beat their swords into plowshares". The naturalism with
which the plants by the porch are drawn is a new feature in his art, but the sense of
spirituality and poetry that marks much of his earlier work is still strongly evoked.

55 · *Study of a Kingfisher*

Watercolour and bodycolour over pencil · 25.8 × 21.8 cm
Presented by John Ruskin, 1875 · WA.RS.RUD.201

In a famous and influential passage in the first volume of *Modern Painters*, published in 1843, Ruskin urged painters to turn away from the conventions of their art and take nature as their model: "Go to nature in all singleness of heart, and walk with her laboriously and trustingly, having no other thought but how best to penetrate her meaning, rejecting nothing, selecting nothing, and scorning nothing". These principles had deeply impressed the young Pre-Raphaelites in the late 1840s and were repeated for a younger generation when Ruskin was elected first Slade Professor at Oxford in 1869. They were again demonstrated in the prints, drawings and watercolours that he gave to the Ruskin School of Drawing, founded by him in the University Galleries in 1871. Many of these drawings and watercolours were made specifically for the school, including this watercolour of a kingfisher, drawn in 1870 or 1871 as an example of natural colour and placed in a cabinet devoted to "Exercises in Colour with Shade on Patterns of Plumage and Scale". No artist perhaps since Dürer has scrutinised the detail and colour of a bird with such a sure hand and keen eye as Ruskin. It was, presumably, drawn from a stuffed specimen but is imbued with such a sense of vitality that this is not immediately obvious.

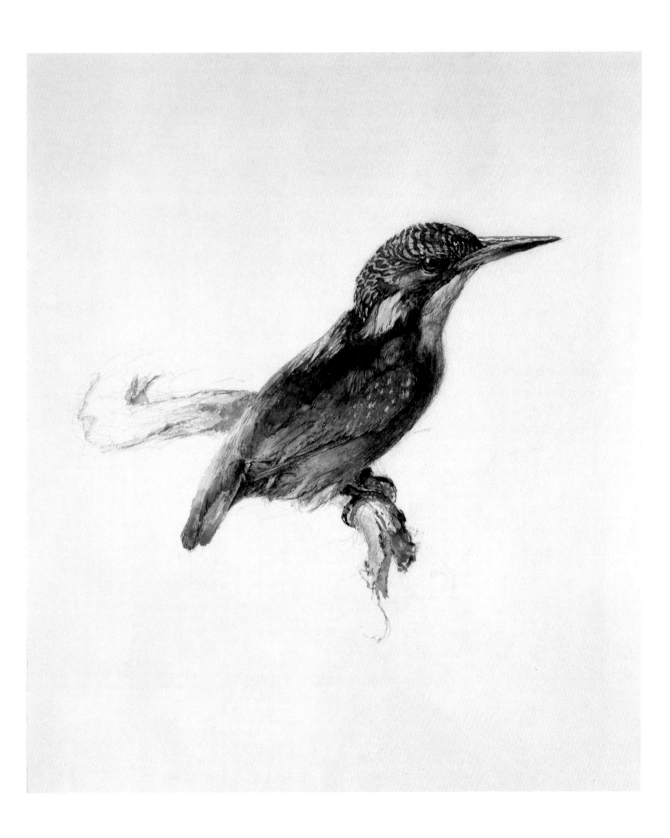

56 · The Race Meeting

Pen and black ink with touches of sepia · 25.4 × 17.8 cm
Inscribed in lower left: JEM/1853 · Purchased, 1947 · WA1947.335

The Pre-Raphaelite Brotherhood, the name adopted by Holman Hunt, John Everett Millais, Dante Gabriel Rossetti and their colleagues for the society which they formed in 1848, was a misleading title for a group of artists who were, on the whole, more attracted by the world of nature than they were by the precursors of Raphael. At first, they chiefly treated subjects from the past, but by the early 1850s, the importance they placed on nature led them towards themes of modern life. Millais's interest in contemporary subjects appears first in a number of drawings, inspired in part by the illustrator John Leech, whom he met in 1853, and, more generally, by the contemporary novel. *The Race Meeting* takes its theme from Leech although the immediate inspiration was an episode seen by the artist at the Epsom races in May 1853: "Such tragic scenes I saw on the course. One moustachioed guardsman was hanging over the side of a carriage … in a state of abject intoxication, while with a white aristocratic hand dangling, as dead a lump, as plaster casts of hands in painters' studios, in the same carriage seated beside him endeavouring to look as if she was not cognisant of the beastly reality; his mistress". The scene in the drawing is somewhat different. Both figures are distraught by their losses, while they are hemmed in by creditors, mocking bystanders and drunken companions. In the man's hat band, a "Derby Doll", a small articulated figure worn in hats during the race, mimics his despairing gesture, while another, like a little mocking demon, sits on the rim of his glass.

57 · Beatrice Meeting Dante at a Wedding Feast Denies him her Salutation

Pen and ink with watercolour on white paper · 34 × 42 cm
Purchased, 1942 · WA1942.156

It is not surprising that Dante Gabriel Rossetti, whose father was a Dante scholar and Professor of Italian literature at King's College in London, found the Italian Middle Ages a source of delight and inspiration. He identified obsessively with his namesake, Dante Alighieri, the thirteenth-century poet whose introspective, autobiographical romance, the *Vita Nuova*, inspired many of his works. The composition of this watercolour broadly follows a passage in Dante's text which describes how the author was overcome by a faint while watching a marriage procession with a friend: "whereupon I remember that I covertly leaned back into a painting that ran round the walls of that house; and being fearful lest my trembling should be discerned of them, I lifted mine eyes to look on these ladies, and then first perceived among them the excellent Beatrice ... many of her friends, having perceived my confusion, began to wonder; and together with herself, kept whispering of me and mocking me". Rossetti combined this episode with an earlier account of how Beatrice misunderstood Dante's intentions and withheld her salutation. Rossetti exhibited a first version of this watercolour in 1852 at the gallery of a dealer, where Ruskin saw it and admired the glorious colour. Rossetti made this second version for a client in 1855 but, in the interim, Ruskin bought it for himself.

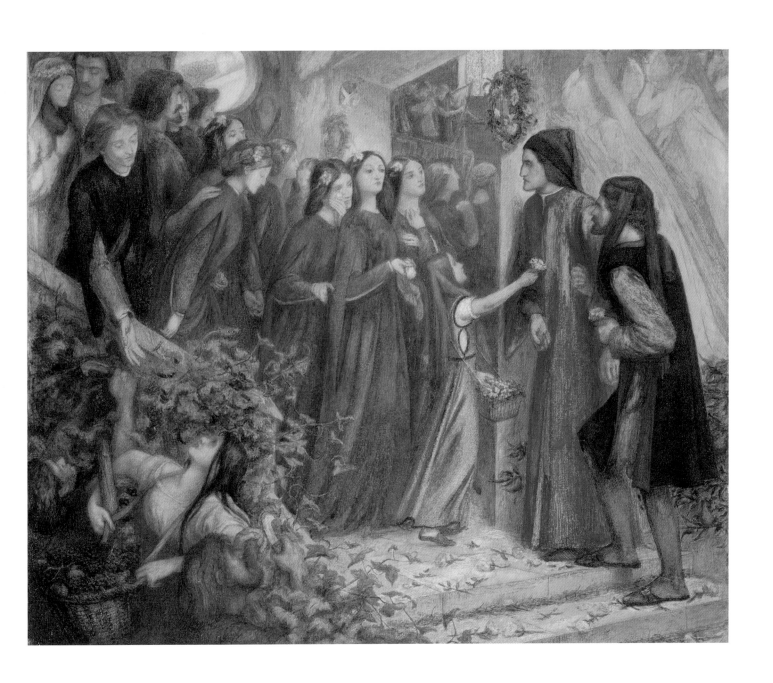

58 · A Young Boy, Seen from Behind, Holding a Basket of Stones

Black crayon, extensively stumped, on thin off-white wove paper · 29.5 × 21.1 cm
Inscribed in black chalk, lower left: *G. Courbet*
Purchased with contributions from the Art Fund, the MGC/V&A Purchase Grant
Fund and the Friends of the Ashmolean by private treaty sale under tax concessionary
arrangements through David Carritt Ltd, 1998 · WA1998.3

Drawings by Courbet are not common. He rarely prepared his paintings with draw-
ings, and apart from his studies of landscape most of his known drawings were
either done for their own sake or were made for reproduction as lithographs. The
road-mender in this drawing was copied by the artist from a figure in his paint-
ing *The Stonebreakers* as the model for a print, first published in 1867. The painting,
illustrating the roadmender's harsh and thankless life, was one of Courbet's earliest
Realist compositions. Following its exhibition in Paris in 1850, it became one of his
best-known works. It was later acquired by the Dresden Museum but was destroyed
during a bombing raid in 1945. Courbet copied the figure in reverse to take account
of the reversing of the image in the printing process. In common with his other
figure drawings, it is drawn with a soft, black painterly touch with little outlining.
This was a manner of drawing used by a number of French artists in the mid-
nineteenth century who, like Courbet, were associated with the Realist movement.
This type of tonal art appealed, in particular, to lithographers.

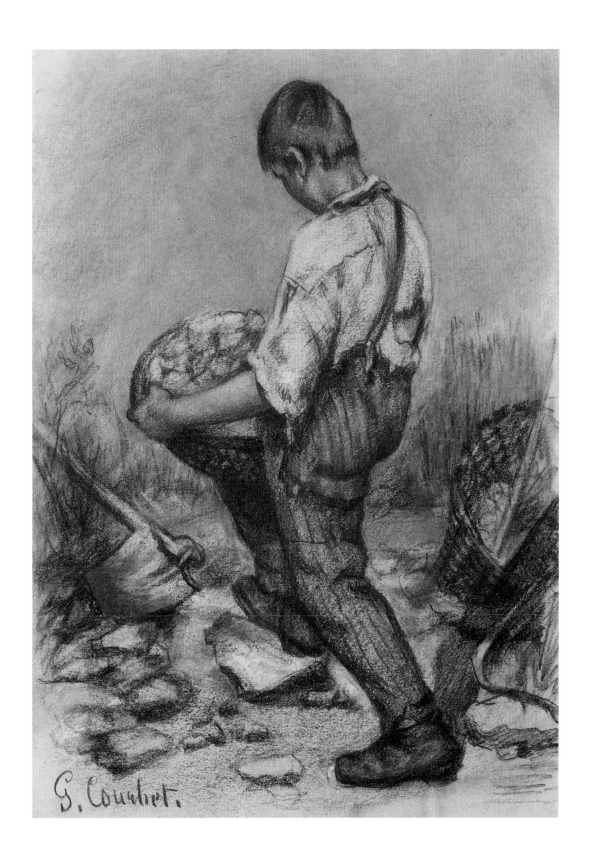

G. Courbet.

59 · A Woman Sewing

Charcoal with stumping and erasures, touched with white chalk · 30.6 × 29.5 cm
Inscribed: 1857 · Purchased, 1935 · WA1935.127

After a brief attempt to obtain training in academic skills at the Ecole des Beaux-Arts
in Paris Fantin-Latour left to complete his education by studying Old Masters at the
Louvre. The painter, François Bonvin, whom he met in 1853, probably encouraged
him to take his subjects from contemporary life. This was a source of themes that
interested other painters and writers in Fantin's circle: Manet, Whistler, Courbet
and Baudelaire. In Fantin's case, it was only one strand and can be seen mainly as an
extension of his work as a portrait painter. From 1855 to 1861, he often took his two
sisters, Nathalie and Marie, as models for a series of drawings, prints and paintings
that share characteristics of both conventional portraits and scenes of daily life. It is
not always easy to distinguish one sister from the other. As a rule, he tended to draw
Nathalie in the act of sewing or embroidering whereas he more commonly drew
Marie absorbed in a book. This drawing is probably a portrait of Nathalie. There
is little outlining in the drawing. The shadows are softly smudged and broadly
hatched while the highlights are suggested with rubbing out and patches of white
chalk. The same manner of drawing is found in Fantin's lithographs, most of which
deal with allegorical and mythological themes.

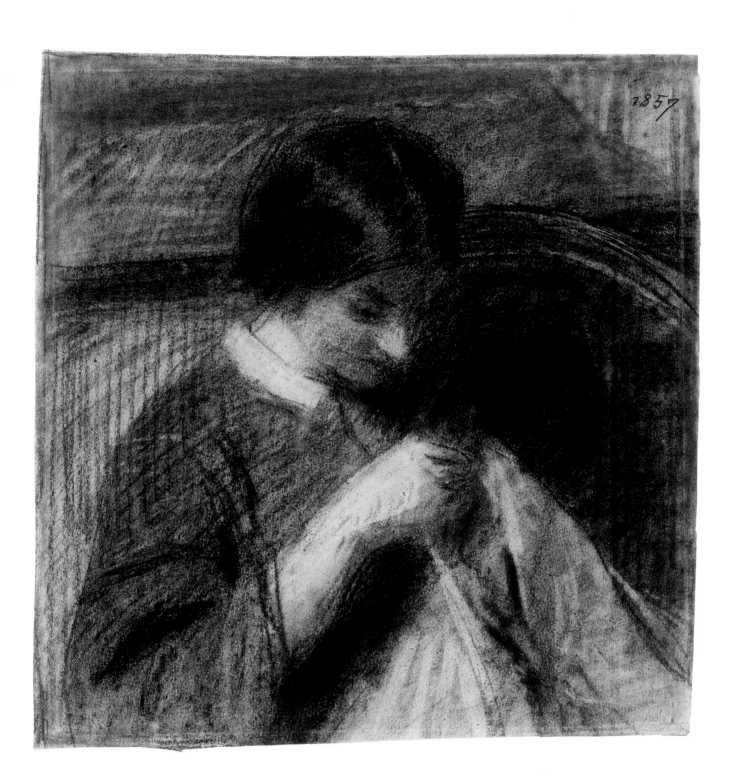

60 · *A Nude Woman, Drying herself with a Towel, Seen from Behind*

Soft graphite, heightened with white chalk,
on heavy, coarse-textured greenish-grey paper · 43.3 × 28.1 cm
Purchased, 1942 · WA1942.102

This drawing corresponds to a bather in an undated pastel, now in the Norton Simon Museum, Pasadena, that once belonged to Claude Monet. The link between the drawing and the pastel is complicated by the fact that the pastel has been drawn over a faint impression of a monotype, a kind of simple print made by painting on a metal plate from which one or, at most, two impressions can be taken. Since the process of making a monotype reverses the image, and since the figure in the drawing is in the same direction as the figure in the pastel, the drawing was probably made when Degas was adding colour to the print and not when he was preparing the original monotype. The addition may have been made between 1883 and 1885 when Degas seems to have added pastel to several monotypes of the 1870s. The same stocky figure appears in two other pastels of the mid-1880s. Like many of the bathers in Degas's pastels, she is unaware of the spectator and the artist, and is seen in a private moment that makes little concession to the common conventions for images of the nude in nineteenth-century art.

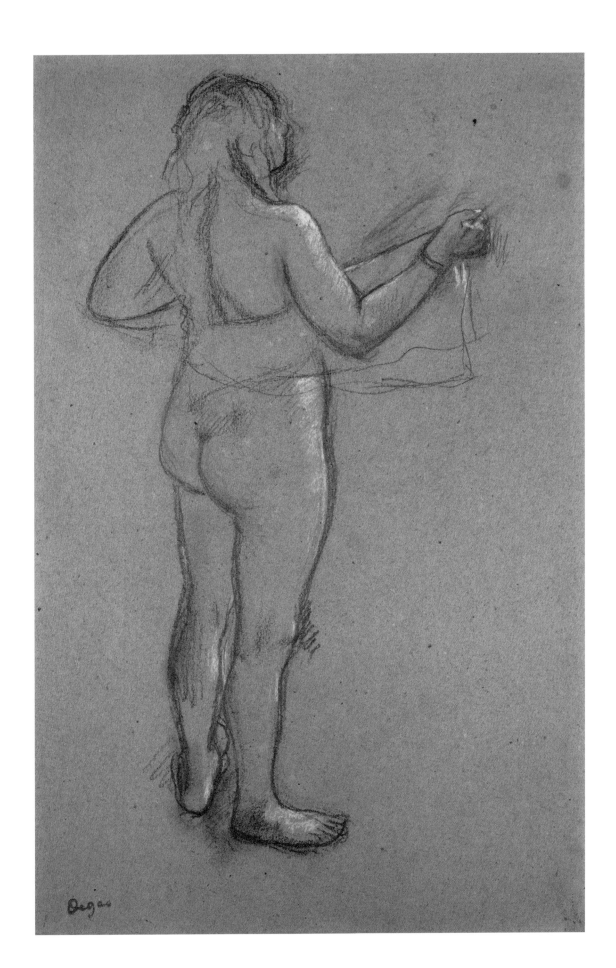

61 · *Female Peasants Placing Pea-Sticks in the Ground*

Gouache with traces of black chalk on grey-brown paper · 40.7 × 64.1 cm
Signed and dated in red gouache lower right: *C. Pissarro 1890*
Presented by Esther Pissarro, 1950 · WA1952.6.310

In the 1870s and 80s, fan painting became popular with French artists as a result of a huge influx of Japanese fans entering the French market, no doubt from the rise in interest of Meiji Period Japanese art. Among the Impressionists, Degas, in particular, enjoyed experimenting with its decorative possibilities. In 1879, he proposed to devote an entire room to fans at the fourth Impressionist exhibition but, apart from Camille Pissarro, his colleagues were less enthusiastic. Pissarro, however, contributed twelve fans and continued to make several dozen more throughout the 1880s. These were not fans for use, but fan-shaped compositions which were made for framing and hanging like conventional paintings and, like Degas's fans, were decorated with compositions related to his other work. All Pissarro's early fans include a semi-circular opening where the sticks would have appeared in a conventional fan, but from 1889 onwards, he painted a number in a simple lunette which gave him a better shape for painting figure groups. The shape of this drawing, with canted corners but flat along the bottom, is not found among his other fans but is well adapted to the group of peasants planting pea-sticks with a lively, dance-like sense of movement in the centre of the composition. The same group reappears in a painting that once belonged to Monet. Whether the painting came before or after the fan has been debated. One might assume that the humble fan was a derivation, but the painting is dated a year later and there is an aptness in the relationship between the composition and the shape of the fan that is not found in the other.

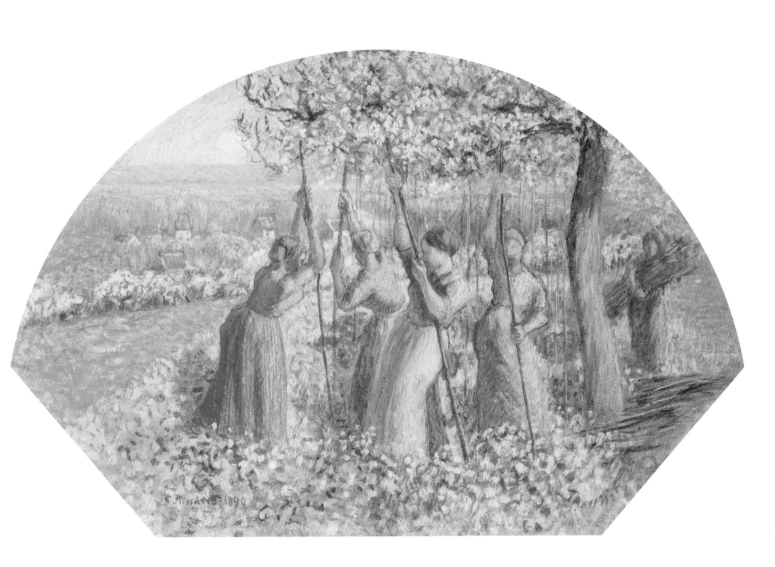

62 · Study of a Young Woman Bathing her Legs

Coloured chalks touched with pastel · 53.1 × 39.1 cm
Presented by Esther Pissarro, 1950 · WA1952.6.360

From his earliest topographical work in the Antilles and in South America to the studies for his later compositions, Pissarro made an abundance of drawings. Most of those which remained in his studio at his death in 1903 have been dispersed, but the largest single surviving group, inherited by his son Lucien when the estate was divided, is now in the Ashmolean. This study was made in preparation for *The Foot Bath* (Collection of Sara Lee Corporation, Chicago), a painting, dated 1895, of a young girl seated on a river bank in slanting sunlight. Pissarro composed a number of pictures of bathers at this time. The theme is common in eighteenth-century French art which was then in high fashion among collectors. The style of drawing in red and black chalk is also reminiscent of eighteenth-century French drawings. Like many eighteenth-century pastoral compositions and like the majority of Pissarro's rustic themes, it presents an idyllic view of rural life. As he wrote to Lucien in April 1894, he was passing the time during a period of bad weather making a quantity of drawings of bathers "in every kind of pose, in paradise landscapes".

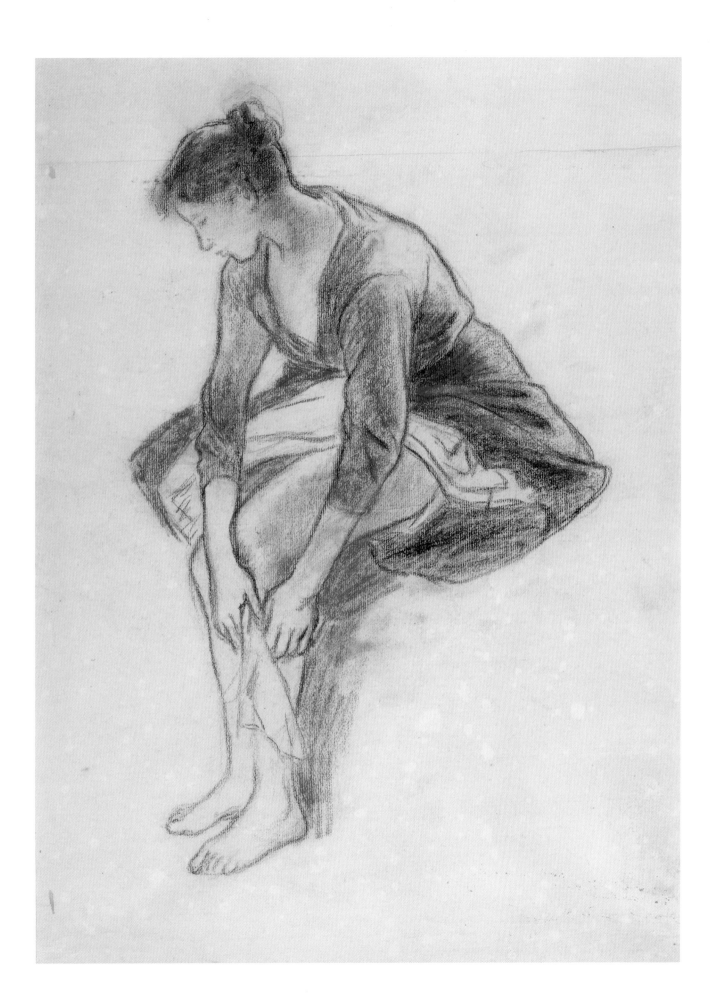

63 · A Seated Jockey, Facing Right

Charcoal, slightly rubbed, with some unrelated touches
of blue pencil on grey discoloured paper · 48 × 31 cm
Bequeathed by John Bryson, 1977 · WA1977.27

From his master, Louis Lamothe, Degas learned the value of drawing in the manner
of Ingres. His earliest drawings are clearly marked by the clear, sharply outlined
manner of drawing practised in Ingres's school. When they met briefly, Ingres's
advice was "make lines, many lines and you will become a good artist". The primacy
of line, advocated by Ingres, even in Degas's latest experimental drawings, remained
the basis of his work. In his first compositions, he took his subjects from the Bible
and from history but, in keeping with a trend towards contemporary life among
his friends, he turned in the 1860s to jockeys, ballet dancers and bathers, subjects
that allowed him to deal with modern life without abandoning the traditional aca-
demic concern with the human figure. His first important racecourse painting, the
Gentlemen Jockeys of 1862, contains a figure very similar to the rider in this drawing
but the thick, improvised charcoal lines are more typical of his later work. Degas
never discarded a good pose, and this figure probably relates to one of two pastel
drawings that he made in about 1882. The spontaneity of the touch and the many
revisions might suggest that it was drawn at the racecourse but it is more likely
that it was drawn from a model in the studio.

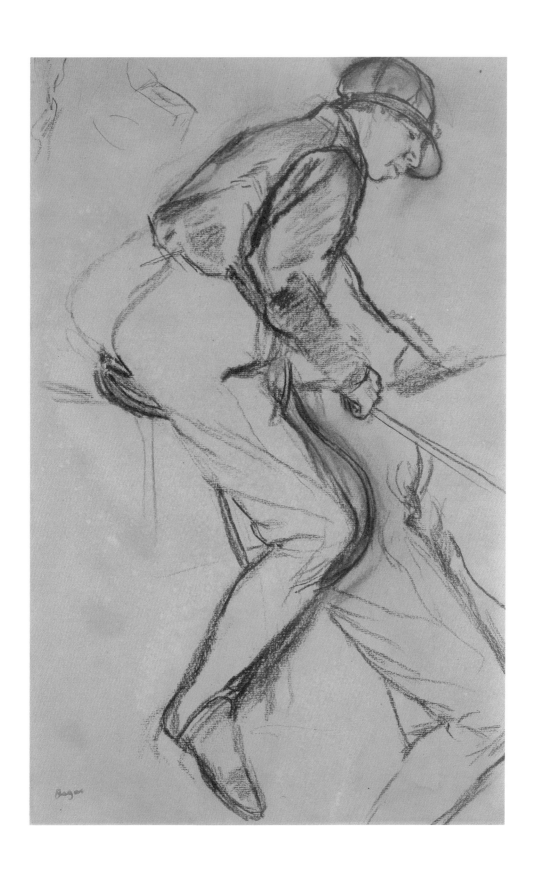

64 · *Still Life of Peaches and Figs*

Watercolour over pencil · 19.8 × 30.7 cm
Presented by H. M. Government from the estate of Richard and Sophie Walzer in
accordance with their wishes, 1980 · WA1980.82

Cézanne took up watercolour seriously in 1866–7. His first watercolours tend to be dense and rough in keeping with his work in oil, but the lightness of the medium acted as a check on the thick, clumsy application of dark paint, which is characteristic of his oils of the 1860s. From the early 1870s, his oil paintings and watercolours developed in tandem towards the luminosity and thin, structured areas of colour which feature in his later work. After 1890, Cézanne began to use watercolour to dissolve form into evanescent patches, but here he uses it to define form with layers of colour of varying density, and for this reason, a date before 1890 has been suggested. It may date from between 1885 and 1890. The plate on which the fruit is placed is seen in recession but the elimination of any sense of depth makes the eye read this as an oval on the surface of the paper. The sheet on which it has been painted may have been twice as large at one time but cut in half to conform to the narrow oblong of the image.

When Bruno Cassirer emigrated from Berlin in 1933, he left a copy of this watercolour in his apartment and took the original with him to England. The copy was confiscated by the German state and sold in Lucerne to a Swiss buyer, who lent it in good faith to a number of exhibitions in the 1950s and 60s as an authentic work by Cézanne. The original meanwhile stayed with the Cassirer family in Oxford and was allocated in 1980 to the Ashmolean, in keeping with the wishes of Sophie Walzer, Bruno Cassirer's daughter, along with several other major works from the collection of her father.

65 · *Design for the Throne Room in 'Le Rossignol'*

Bodycolours · 101 × 109 cm
Signed, dated: *Alexandre Benois 1914*
Bequeathed by Mikhail Braikevitch, 1949 · WA1949.316

Benois was born in St Petersburg, son of an architect of French descent. Although he graduated in law, he came to notice through his watercolours and went on to become a very influential book illustrator, theatre designer, painter and art historian. In 1901, he was appointed scenic director at the Mariinsky Theatre in St Petersburg and held the post of curator of Old Masters at the Hermitage Museum from 1918 to 1926. He was also one of the founding members of the "World of Art" movement and played a prominent role in the early years of the Ballets Russes, designing sets and costumes for several of Diaghilev's most famous productions. This spectacular design was made for Act II of Igor Stravinsky's musical drama, *Le Rossignol*, produced by Diaghilev at the Paris Opera in 1914. The libretto, based on Hans Christian Andersen's Chinese tale *The Nightingale*, was written by Stravinsky and Stefan Mitussov. At the beginning of the act, couriers festoon the room with lanterns; a procession enters followed by the Emperor who commands the bird to sing. The bird then sings one of the set pieces of the opera. The scattered lamps and lanterns seen here against a background of royal blue must have had a magical effect in the theatre. In 1920, Diaghilev adapted the music for a ballet with choreography by Massine and décor and costumes by Matisse. Benois prized his sets for *Le Rossignol* and never forgave Diaghilev for discarding them in favour of Matisse's.

66 · Portrait of Elena Ivanovna Roerich

Black chalk, pastels and watercolour, touched with bodycolour,
on straw-coloured paper · 64.8 × 46.6 cm
Signed: BC 909 (VS 1909) · Bequeathed by Mikhail Braikevitch, 1949 · WA1949.340

Serov was one of the greatest portrait artists of his generation. In his more formal commissions, he adopted a style partly derived from French Impressionism, partly from Frans Hals, Velasquez and the Old Masters, but he also produced many less formal, light-filled paintings of children and landscape. By the early 1900s, his portraits had become more economical and linear in response to the decorative tendencies of the "World of Art" movement. This portrait was drawn in 1909 and combines fluent contours and a certain simplification of form with a keen sense of character. The sitter Elena Roerich, née Shaposhnikova, married the painter Nikolai Roerich in 1901. From 1924 to 1928, they travelled through Tibet, Mongolia and other remote parts of Central Asia before returning to India where they set up home. Elena wrote extensively on philosophy and ethics, inspired by her interest in Buddhism. Despite several attempts to return to Russia in later life, she remained in India and died in Delhi in 1955.

67 · *Noctes Ambrosianae*

pastel · 46.4 × 59.7 cm
Presented by the Christopher Sands Trust, 2001 · WA2001.36

After spending four years on the stage, Sickert took up a career in painting. He went, at first, to the Slade School and then completed his training as Whistler's pupil and assistant. The theatre, however, remained important to him as a source of inspiration. His use of theatrical subjects was encouraged by the work of Degas, whom he met in 1883, and, more generally, by the work of nineteenth-century French artists who took their subjects from popular culture. His first paintings, dating from the 1880s, illustrated scenes from the London music halls. He executed these and many other subjects from modern urban life with drab colours and a flat, dry touch that mirrored the colourless existence of the people whom he painted. *Noctes Ambrosianae* (Ambrosian Nights) is set in the Middlesex Music Hall in Drury Lane, known popularly as the Mogul Tavern or the 'Old Mo'. The idea of depicting the spectators, crowded into the cheapest seats in the gallery, was taken from earlier French prints, particularly from Daumier's lithographs, illustrating the audience's response to the action on the stage. The title, however, was taken from a series of imaginary conversations, published in *Blackwood's Magazine* from 1822 to 1835. These were set in a fictional Ambrose's Tavern in Edinburgh which, like the Mogul Tavern in London, was a place of popular entertainment. But he also adopted the title because, in mythology, ambrosia is the food of the gods, and the "gods" is a theatrical term for the gallery.

This was one of Sicket's favourite compositions. He repeated the original oil of 1906 in this pastel and again in an etching in 1908. The crowd is shown enraptured with the performance and straining to see it from the height of the gallery. Sickert himself looks upwards from the more expensive stalls and paints his subjects with some humour but with little noticeable sympathy. As in all his subjects of modern life, he viewed what he painted with a rigorous and sometimes bleak detachment.

68 · *Portrait of Aircraftsman T. E. Shaw* (*Lawrence of Arabia*)

Charcoal on white paper
Inscribed in charcoal, lower right: John to Shaw/ 1935 · 50.5 × 35.5 cm
Presented by Professor A. W. Lawrence, 1947 · WA1947.164

Augustus John met Lawrence for the first time in 1919 at the Paris Peace Conference at the end of the First World War. John went there to record the conference in a painting, while Lawrence was attempting to secure independence for the Arabs. The friendship that began at the Hotel Majestic (where the British delegation had been installed) was close and lasted until Lawrence's death. In January 1935, during Lawrence's last visit to his studio at Fordingbridge, John drew two portraits of his friend, one of which, according to the sitter, was "good about the knees, but poor in the head". The other, the present drawing, showing Lawrence in the uniform that he had worn since joining the RAF, was inscribed by the artist and given to the sitter. It shows Lawrence in an informal pose, as if leaning on a mantelpiece, and is inscribed to "Shaw", the surname Lawrence adopted when he joined the Royal Tank Corps in 1923. Like most of John's drawings, it has a strong linear character, in keeping with his early training at the Slade School where the importance of fine line drawing was emphasised. Lawrence was immensely pleased with the likeness and immediately ordered 100 reproductions for a projected private publication of *The Mint*, an account of Lawrence's life in the RAF. This project, however, was abandoned when Lawrence died in a road accident four months later.

John
to
Shaw
1935

GWEN JOHN 1876–1939

69 · A Seated Girl

Charcoal, grey wash and bodycolour on grey paper · 32.4 × 24.9 cm
Presented by Ursula Tyrwhitt, 1964 · WA1964.84.5

Like her brother, Augustus, Gwen John acquired a talent for fine drawing in the 1890s while studying at the Slade School in London. In 1903, she settled in France, living at first in Paris and then, from 1910, at Meudon where she associated with the nuns at the local convent. She converted to Catholicism in about 1913. The format of this watercolour and of many of her paintings and drawings from this time onwards was based on a portrait of a seventeenth-century nun, Marie Poussepin, of which John painted at least six copies for the nuns in Meudon. This portrait was probably drawn at Pléneuf, a coastal village in Brittany where John stayed in 1918–19, making many drawings of the local girls. In common with a number of these drawings, the subject is seated with her hands in her lap in the manner of Marie Poussepin. The identity of the sitter is not known for certain, but she may be Marie Hamonet who lived at Pléneuf and was one of John's favourite models. Her drawings from this period are executed with rapid outlines and filled in with flat, muted washes. There is, perhaps, an echo of Whistler's work in their spare, reductive character and a more direct but less obvious debt to Rodin's wiry drawings of the human figure.

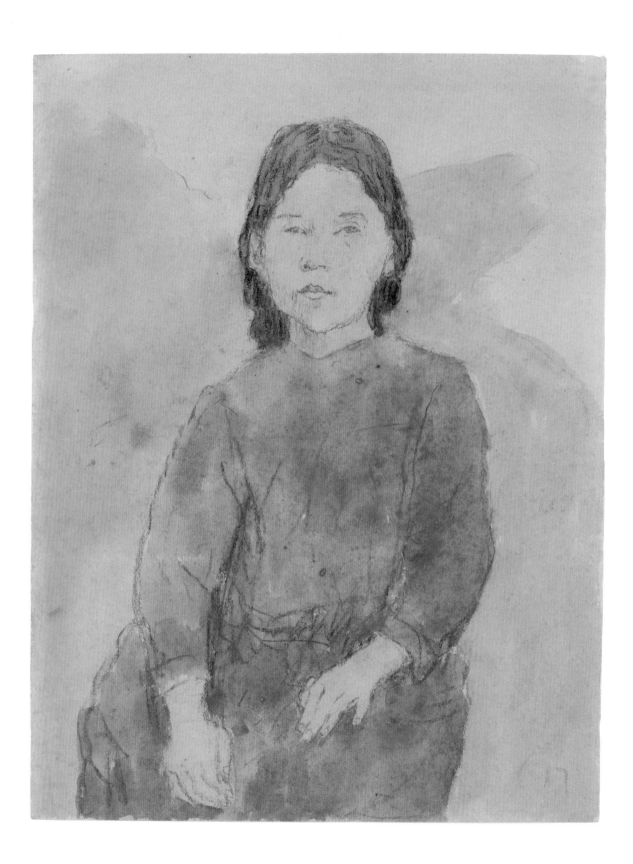

70 · Learning to Be

Carbon and casein on paper · 19.1 × 13.7 cm
Inscribed on the verso with the title, signed with initials and dated: A.M.D.G. '93
Purchased with funds from Mr and Mrs Raphael Bernstein, 1994 · WA1994.67 · © the artist

In the 1980s, Gormley began to make casts of his own body which he turned into a series of featureless, standing figures in lead, fibreglass and cast iron similar to the stark, male nude in this drawing. The title refers to a standing figure, cast in lead in 1992, now in the garden of Lismore Castle in County Waterford in Ireland. The figures in the sculpture and in the drawing are also similar, although the drawing is not sculptural in any conventional sense. The bodyform is solid, heavy and robust, while the figure in the drawing is flat, thin and frail. The sooty blackness of the pigment, melting into the absorbent paper, gives it an insubstantial air, softly washed in silhouette against a flood of light. The frailty and anonymity of the figure suggests a survivor of some catastrophe, a victim of persecution, or an image of Everyman learning, as the title implies, to exist in an uncertain world. Several of Gormley's figures echo the image of the crucified Christ, a relic, perhaps, of the sculptor's own religious upbringing. The initials with which he has signed the drawing are both a reference to his name, Antony Mark David Gormley, and to the Latin *Ad Maiorum Dei Gloriam*, the motto of the Jesuits: 'to the greater Glory of God'. It was perhaps a sense of spiritual mission which encouraged Gormley to abandon abstraction and return to the human figure in the 1970s. "I am tired of art that is about art," he once said; "I am now trying to deal with what it feels like to be a human being."

71 · *Henry Writing, Lucca, August 1973*

Pen and black ink on white paper · 43.1 × 35.5 cm
Inscribed: *Henry writing, Lucca, Aug 73*; and signed: *dH*, lower right
Presented by the Friends of the Ashmolean to commemorate Lord Bullock's
chairmanship of the Friends, 1976–1996 · WA1996.28

David Hockney first met Henry Geldzahler, the subject of this drawing, in New York
in 1963. Geldzahler was then curator of twentieth-century art at the Metropolitan
Museum, and Hockney was a young member of the British Pop Art movement.
The two were introduced by Andy Warhol and formed an immediate friendship.
Between the 1960s and Geldzahler's death in 1994, Hockney made several portraits
of his friend in paintings, drawings and prints. The present portrait was drawn in
1973 in Lucca where Hockney and Geldzahler had rented a villa for the summer. By
this date, Hockney had turned away from the rough graffiti-like manner of his early
works and had adopted a cooler and more naturalistic manner of painting. His style
of drawing also had become more precise and representational, particularly in the
lively, affectionate portraits that he drew of friends and colleagues. Bad drawing,
he told an interviewer, is like "figures that you don't feel about, that you don't care
about". The linear manner of these portraits recalls the work of Picasso from the
1920s when he, too, was revising his relationship with contemporary art by turn-
ing back to an earlier and more traditional style. Hockney's touch is lighter than
Picasso's and appears, at first glance, simpler and more improvised. The image is,
however, intensely observed and drawn with a painstaking care that might, in the
hands of a lesser artist, have deadened the effect. In Hockney's hands, the line seems
effortlessly delicate, drawn with a warmth and vitality that brings the image of
Geldzahler vividly to life. He is shown, sitting at a table, typing the text of Hockney's
first major book, *Hockney on Hockney*, first published in 1976.

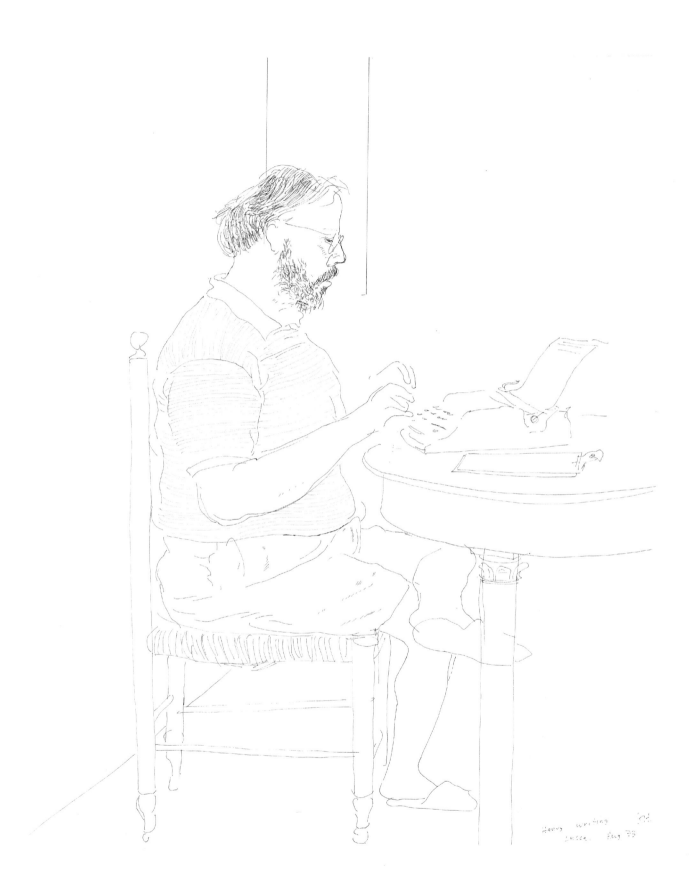

Henry writing '85
Lucca. Aug 85

THE DRAWINGS COLLECTION

Visiting the Ashmolean Western Art Print Room

The Ashmolean Drawings Collection is accessible, not just to students and scholars, but to everyone. Delicate drawings and watercolours have to be protected from fading by being stored away from direct light, but a combination of traditional study and store rooms and up-to-the-minute modern technology means that you can be looking at the drawing of your choice within minutes of entering the Museum's Western Art Print Room. It is wise to telephone in advance (01865 278049) or email (waprintroom@ashmus.ox.ac.uk) to reserve a seat. If you want to look at the exceptionally valuable drawings by Raphael or Michelangelo, which require special care for conservation reasons, at least twenty-four hours notice is required.

The Ashmolean's collection of drawings and prints is being made available online, so that it can be browsed or searched before you visit the Print Room. Go to www.ashmolean.org and click on the link Online Collections. You will be given the choice of searching drawings or prints. At the time of writing, the French, Italian, nineteenth-century German and Russian drawings collections, as well as the great majority of the fifteenth- and sixteenth-century Italian prints are online. Drawings and prints by and after Rembrandt can be found by clicking on Rembrandt Collection. The Ruskin Collection is available in its entirety. Not only can you see what is available; in some cases you can zoom in on images, and examine details.

Many of the drawings in the collection can be found in the Museum Shop, either as prints, postcards, or in specialist books. You can also order prints from the Picture Library (http://www.ashmolean.org/services/picturelibrary/) or visit the easily searchable online print-on-demand service (http://www.ashmoleanprints.com/). This provides prints of various sizes and textures, framed and unframed.

Artists in the collection include: Albrecht Altdorfer, Léon Bakst, Max Beerbohm, Alexander Benois, William Blake, Hieronymus Bosch, François Boucher, Edward Burne-Jones, Antonio Canaletto, Lodovico Carracci, Claude Lorrain, John Sell Cotman, David Cox, John Robert Cozens, Edgar Degas, Anne Desmet, Albrecht Dürer, Caspar David Friedrich, Thomas Gainsborough, Thomas Girtin, Francisco Goya, Mathis Grünewald, Francesco Guardi, Guercino, David Hockney, Edgar Holloway, William Holman Hunt, Jean-Auguste-Dominique Ingres, Augustus John, Gwen John, Konstantin Korovin, Edward Lear, Leonardo da Vinci, Michelangelo Buonarroti, John Everett Millais, John Nash, Paul Nash, Adriaen van Ostade, Samuel Palmer, Leonid Pasternak, Pietro Perugino, Camille Pissarro, Nicolas Poussin, Raphael, Rembrandt van Rijn, Dante Gabriel Rossetti, Paul Sandby, Walter Sickert, Stanley Spencer, Giovanni Battista Tiepolo, Jacopo Tintoretto, Titian, J.M.W. Turner, Leon Underwood, Jean-Antoine Watteau

INDEX OF ARTISTS